MILWAUKEE
AT MID-CENTURY

THE PHOTOGRAPHS OF LYLE OBERWISE

MILWAUKEE COUNTY HISTORICAL SOCIETY

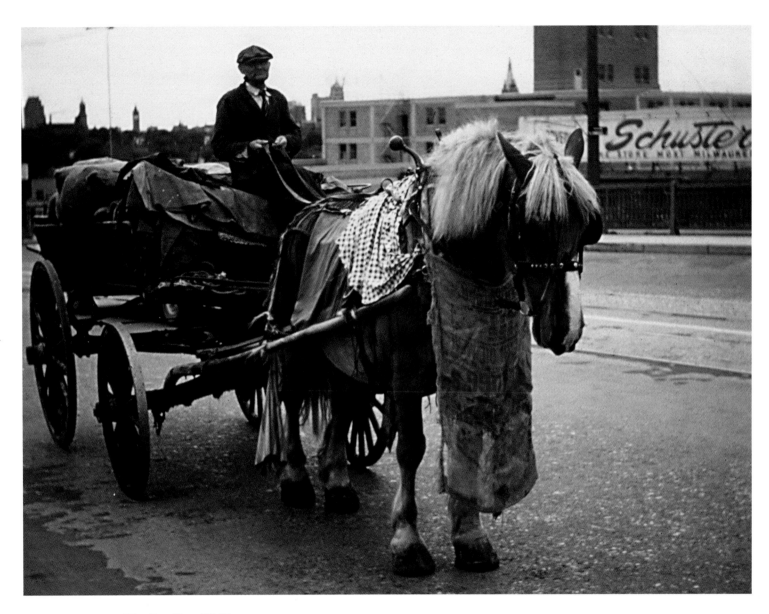

The Rag Man (1948) –
The Rag Man and his horse-drawn wagon were a
familiar sight throughout Milwaukee into the 1950s, and
his heavily-accented call was one of the most distinctive
sounds of the middle of the twentieth century. Here the
Rag Man and his buckboard cross the Holton Street viaduct
adjacent to Schuster's warehouse. The warehouse has recently
been converted into apartments as part of the
housing boom in downtown Milwaukee.

MILWAUKEE
AT MID-CENTURY

THE PHOTOGRAPHS OF LYLE OBERWISE

Funded by grants from

The Lynde and Harry Bradley Foundation

The Greater Milwaukee Foundation
Leslie Bruhnke Fund
ELM II Fund

The David and Julia Uihlein Charitable Foundation

MILWAUKEE COUNTY HISTORICAL SOCIETY

Published by the
Milwaukee County Historical Society
www.milwaukeecountyhistsoc.org

Copyright ©2007
by the Milwaukee County Historical Society

Cover Illustrations:
Front: Milwaukee Road Depot, 1948
Back: Milwaukee County School of Nursing, 1956

Printed in the United States of America
by Burton & Mayer, Inc., Brookfield, Wisconsin

Designed by Victor DiCristo,
WP&T (Wunderlich, Pearson and Tetzlaff)
Wauwatosa, Wisconsin

Library of Congress Control Number: 2007933757

ISBN-13: 978-0-938076-19-3

TABLE OF CONTENTS

MILWAUKEE

FOREWORD

FOREWORD

When John Angelos stood in line outside an eastside Milwaukee apartment building in April of 1994, his hopes for finding treasure at the estate sale being held inside were small. The ad in Sunday's Milwaukee Journal had promised "many historic Milwaukee photos," but Angelos knew from experience that "many" could mean no more than a dozen and "historic" might mean nothing more than old folks in beards or long dresses.

Once inside the fourth-floor walk-up apartment, though, Angelos knew he had found something extraordinary. "Many," he discovered meant an entire bedroom filled with boxes of Kodachrome slides. "Historic," he would eventually come to understand, meant a detailed record of Milwaukee as it had evolved over the twentieth century. And a not-very-promising rummage sale would mark the beginning of a project that would occupy Angelos for the next decade – a project that would eventually involve many other Milwaukeeans and would ultimately result in this book.

When Angelos wrote and sealed his bid for the "many historic photos," he estimated that "many" meant "about 10,000 slides" plus several albums full of black and white photos. He had had just fifteen minutes to examine the material and had been able to look into only a few of the boxes before making his bid. Notes in the albums identified the photographer as "Lyle Oberwise," and a numbering system on the boxes provided a rough chronology, but no one seemed to have any more information about the photos or the photographer.

Over the ensuing months Angelos would spend countless hours examining the slides and would revise his count upward to "over 43,000 slides." With help from the late Frank Zeidler, he would begin to identify the locations of some of the photographs. Old city directories would become his most valued tools.

As he worked with the photos, Angelos began to see a Milwaukee he had never known – the city as it was before he moved there in 1971. The photos, however, were also showing him a city that he had known – a city that had disappeared over the past twenty-five years. Furthermore, they were evoking a great nostalgia for Milwaukee as it had once been. Others, he thought, would likely feel the same nostalgia. So in June 1994, Angelos and I invited a couple dozen friends to view a small sample of the slides; with luck, our friends would help us identify some of the buildings pictured.

Among the guests for that first slide show – which incidentally went on well into the night and required a second beer run – were both newcomers, amazed at what they were seeing, and life-long Milwaukee residents eager to share information and memories. Three of the guests that night deserve special mention because their help was instrumental in bringing these photos to the Milwaukee community: then-Mayor John Norquist who repeatedly used his "bully pulpit" to emphasize the historic importance of the Oberwise Collection; Susan K. Bromberg, president of Historic Milwaukee, Inc., who organized the first public slide shows of the Oberwise photos; and *Milwaukee Journal* reporter Tom Strini who convinced his bosses that the Oberwise story deserved a feature length article complete with color photos.

Strini's article, published in the December 11, 1994 *Wisconsin* magazine, brought responses from dozens of readers who wrote of memories evoked by the photos. The article also brought letters from people who had known Lyle Oberwise, and it piqued the curiosity of another *Journal* reporter, Jim Stingl, who wrote a follow-up article in February 1995. It is from those letters, from Stingl's work, and from information gleaned at the many subsequent slide shows and print shows that we have constructed a sketchy biography of the mysterious man who made the 43,000 photographs that now comprise the Oberwise Collection at the Milwaukee County Historical Society.

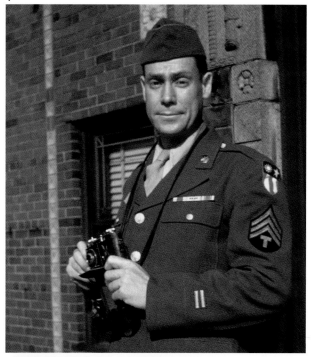

Lyle Oberwise

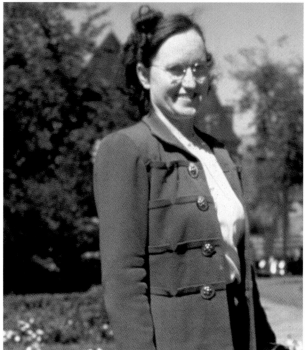

Agnes Goodrich Oberwise

Lyle M. Oberwise was born in Batavia, Illinois, July 5, 1908. He was the son of Matthew Oberwise who died in 1934 at age 50 and Laura Monahan Oberwise who died in 1957 at age 70. In 1939 Lyle Oberwise married Agnes Goodrich. On September 26, 1993 he died at age 85. That is the public record. What little more that is known of Oberwise's life has been filled in by his few friends who, to a person, describe him as "intelligent," "quiet" and "shy."

Oberwise grew up near Batavia in Kane County, Illinois. In 1926 he graduated from St. Charles [Illinois] High School, but he had spent only his senior year there and was described by classmate John Gricunas as "a quiet lad," "a real quiet guy, a real loner" who "liked to keep to himself." "But he was one of the smartest kids in the school." After 1950, Gricunas lost track of his high-school friend, but in about 1990, the two men met again. Gricunas told the *Kane County* [Illinois] *Chronicle* that he had seen "literally hundreds of boxes full of photos and slides" at Oberwise's apartment. "I told [Lyle], 'Lyle, why don't you catalog these and get them organized?'" but Oberwise answered that he didn't have time to organize the slides. Nevertheless, Angelos found the slides meticulously organized. From the beginning, Oberwise had neatly labeled, numbered and stored them in chronologically ordered boxes.

After high school, Oberwise attended Marquette University and graduated with an engineering degree in 1931. He served for a few years in the Civilian Conservation Corps, and later in the 1930s he worked for Milprint, a Milwaukee manufacturer of packaging materials. His job there, as described by a co-worker, Oliver Friedl, "was to take the bags out of the machine hopper," "inspect and cull out any that were imperfect [and] place them by 50's in a cardboard box." Whether Oberwise took a factory job by choice or because few engineering jobs were available in the 1930s Depression years, we cannot know. In any case, Friedl remembered Oberwise as a hard worker: "When the machine was down … Lyle would immediately grab a broom and start cleaning the dept."

By the early 1930s, Oberwise was already an accomplished amateur photographer. Many fine black and white photos of downtown Milwaukee in the 1930s survive in his albums and attest to his skill. The photos also tell us that he was already engaged in what would prove to be his lifelong project of recording Milwaukee's streets and buildings.

During World War II, Oberwise was drafted into the Army, trained as a combat photographer, and served with the 3374th Signal Photo Corps in the China-Burma-India theatre. Somehow, during his service in the Far East, he was able to obtain Kodachrome, a color film that Kodak had just introduced in 1935. The film was expensive to buy, expensive to develop and, generally speaking, too finicky for field conditions – not a film suited to combat situations. So how Oberwise got his film, where he had it developed, and where he might have stored either the film or the developed slides until he returned home are questions that we cannot answer. We do know, however, that he produced many technically and artistically fine photos while on leave in Calcutta and just after the war in Shanghai. We also know that Kodachrome would remain his film of choice for the remainder of his life. That was a fortunate (and, perhaps, fortuitous) choice, since it has proven to be an extremely stable medium, preserving color far better than many other contemporary films.

Upon returning to Milwaukee after World War II, Oberwise went back to his job at Milprint. During his years there, he frequently photographed Milwaukee's Menomonee River Valley from the roof of the Milprint Company, giving us a valuable record of the city's industrial history.

Sometime in the 1950s, he took a job at General Electric's Apparatus Service Center where he would work for twenty-two years until his retirement. A manager at the Service Center, Henry Heykes, remembered Oberwise as "very quiet" and "one of the hardest working employees we had. He kept to himself" and "always had his camera with him. [Lyle] always told me," Heykes wrote in 1994, that "he loved to take pictures of 'Milwaukee'" and that was "how he spent all of his spare time."

Eugene F. Knol, who as a young man roomed with Lyle and Agnes Oberwise during the late 1950s and early 1960s, provides a rare look at Oberwise's personal life. In a 1995 letter Knol described Oberwise as an early riser; "quiet and even tempered;" a non-smoker and a person who only "enjoyed an occasional beer;" a practicing Catholic; a regular and avid movie-goer; and a man with a subtle sense of humor. Knol also provides some insight into Oberwise's photographic habits.

According to Knol, by 1960 Oberwise already had many "book cases filled with boxes and boxes of slides" but did not own a slide projector or a screen. To view his slides, he had to hold them up to a light and squint at the 35mm images. During the years Knol lived with him, Oberwise, who never owned a car, would spend his Sundays walking the streets of Milwaukee taking pictures – photographing construction projects, demolition projects, girls at Bradford Beach and what he described to Knol as "whatever." "He seemed," wrote Knol, "intent upon … preserving, through his photographic skills, changes in physical appearances as well as social mores."

That commitment to preserving a record of change remained through Oberwise's retirement years. On July 10, 1993, only two months before his death at age 85, he wrote a letter to his friend and fellow CBI veteran Clarence Miller detailing the many demands upon his time and energy. First, there was news, both local and national, to keep up on: "Dahmer, Bembeneck, the 'Wacko from Waco', Twin-tower bombing, serial killers, mass murders, rapes, child abuse, harassment, drive-by shooting, home intrusion, Gays, Lesbians, and protestors for no-win Causes by local zealots."

Mitchell Park Baseball Field and Menomonee River Valley, 1947

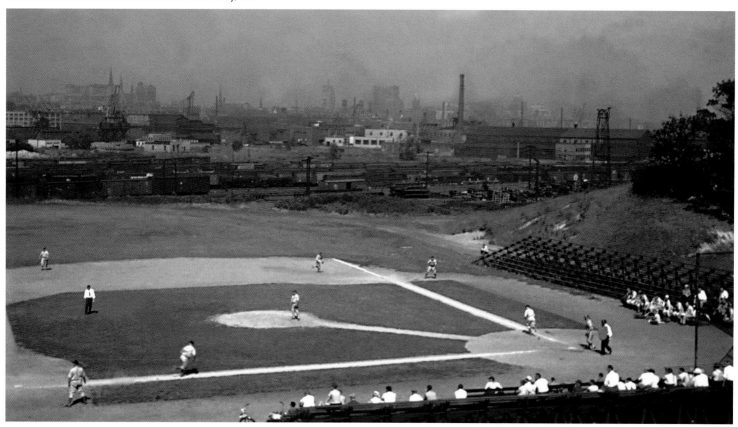

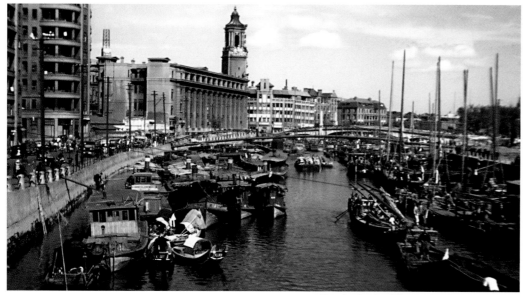

Shanghai, Looking West on Soochow Creek, 1945

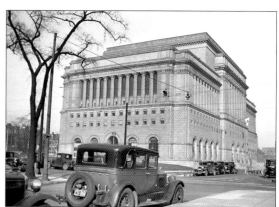

Milwaukee County Courthouse, 1930s.

Then there were the many events he wished to photograph. Competing for his attention that summer were Bastille Days, the Circus Parade, the Memorial Day parade, a motorcade with President Clinton, RiverSplash fireworks and a Harley-Davidson parade.

To that he added a list of on-going projects that he tried to keep track of on a weekly basis: "Sunday is a day I can walk around the downtown and have the streets to myself." With the streets to himself, he could record developments at the O'Donnell Parking Garage terrace, the Miller Pavilion and Transit Center, the Ambrosia Chocolate demolition, the Marquette University Campus Circle, the new Wisconsin Avenue Bridge, an addition to East Pointe Commons and the American Motors building demolition which required a long bus ride from his State Street apartment. Occasionally even the weather warranted a photograph if it "afforded cloud studies, especially Cumulus." Always an attentive observer, even as age made it more difficult to walk the streets of Milwaukee, he continued to use his camera to record and preserve the scenes, events and changes that he witnessed. When he died in September, he carried a fresh roll of film in his pocket.

In the decade that followed Angelos' purchase of the Oberwise slides, he and I presented dozens of public slide shows to thousands of viewers. Among the sponsors who organized and supported these showings were Historic Milwaukee, The Park People, the Washington Heights Neighborhood Association, church groups, high school reunions, women's clubs and civic groups. Two gallery shows of photos printed from Oberwise's slides were sponsored by the Milwaukee Institute of Art & Design with support from the Harry and Mary Franke Idea Fund, the Wisconsin Humanities Council, the Wisconsin Arts Board, Miller Brewing Company and Enlargement Works. Without the generous help of these and many other groups and individuals, the task of sharing Oberwise's work with Milwaukee might well have overwhelmed us. We are thankful to them, for without their help the Oberwise treasure might have remained buried.

But as valuable as this support was, we feel a special gratitude to the hundreds of people who responded to Oberwise's photos with stories of their own. Not only did they provide us with valuable information about buildings and events Oberwise photographed, but they also shared with us their own memories. And those memories then became part of the slides' continuing narrative. Thus Rosenberg's became not just a store at Third and North, but "the place to buy your wedding dress if you were a bride in the 1940s." Eugene's became known as a favorite place for a young man to propose to his girlfriend. The Plankinton Arcade became a place where high school girls flirted with sailors on leave. And a 1947 Buick became "our first car after the War." Oberwise's photos, most of them devoid of people, came, in this way, to be inhabited by the viewers; and those viewers, in the telling of their own stories, passed on to others a history far richer than the public record alone can reveal.

Over the years that John Angelos and I owned the Oberwise photos, we were often told of Oberwise's reluctance to show his slides to anyone. "He would come to meetings of our CBI group," a fellow veteran told us, "but we never knew he had pictures of China and India." "We knew he took pictures, but we never saw any of them," wrote a one-time neighbor. "Lyle told [us] he had 10,000 slides, but we never saw any of them," a niece of Agnes Oberwise said. "I think he might have been too shy to show them," Rudy Kuzel, a friend of the Oberwises told us after seeing a show of Lyle's work. "I like to think, though, that he's looking down and is pleased to see so many people looking at his pictures." We, too, like to think he would be pleased with the attention his work has received and that he will be pleased that this book brings his pictures to so many more people.

Marilyn L. Johnson
Wauwatosa, Wisconsin

MILWAUKEE

ACKNOWLEDGMENTS

ACKNOWLEDGMENTS

In March, 2003, nine years after rescuing the photographs of Lyle Oberwise from an uncertain fate, John Angelos and Marilyn Johnson offered the collection to the Milwaukee County Historical Society along with several other significant bodies of work by local photographers. They made their generous offer for several reasons. First, they felt the Oberwise images had to remain in Milwaukee so that they would be available to the people who would make the most use of them. Second, they felt the collection should not be dispersed to a number of institutions but rather should remain intact so that researchers would have the easiest access to all of Lyle Oberwise's wonderful photographs. And, third, they felt that adding the Oberwise Collection and their several other collections to the total of nearly 500,000 images already held by the Milwaukee County Historical Society would not only strengthen the organization's holdings but also assure their long-term preservation for the benefit of the entire community. So committed were John and Marilyn to the idea of their collection going to the Historical Society that they allowed us more than six months to secure a grant from The Lynde and Harry Bradley Foundation to purchase it. Their thoughtfulness and generosity in ensuring the continued availability of the Oberwise Collection to the Milwaukee community cannot be overemphasized!

Following the acquisition of the Oberwise Collection, the staff of the Historical Society's Research Library, along with a committed group of volunteers, undertook the daunting task of organizing the photographer's 43,000 images in a way that would make them most easily accessible to scholarly researchers and the general public. Curator of Research Collections Steve Daily and Assistant Curator Kevin Abing, along with library volunteers Dave Kosmider, Ed Larsen, Dan Emmer and Steve Lorbeck, sorted and re-sorted the Oberwise photographs into categories which included public buildings, parks and recreation, commercial buildings, neon signage, transportation and streetscapes. Within those categories, further subcategories were identified and defined so that the entire collection is now thematically arranged in a manner which permits the most convenient use.

While the Research Library staff and volunteers were sorting and cataloging the Oberwise images, I assumed the role which Marilyn Johnson had played for many years, presenting his photographs to the larger public through informal slide lectures. No matter whether these talks were presented to local historical societies, senior citizens groups, or retirement communities, the response was always the same – Lyle Oberwise's color slides brought back memories so vivid that audience members had to share them. In much the same way as John and Marilyn had learned more about Milwaukee and about Lyle Oberwise through their presentations, so too were we able to gain additional insights from Oberwise's colleagues in the China – Burma – India Veterans Association, from acquaintances of his wife Agnes and from former co-workers. The resulting interaction always made for lively programs and for repeated requests that the Oberwise photographs be made available in book form.

The thought that a sampling of photographs from the Oberwise Collection might eventually be published crossed the minds of the Research Library staff and volunteers while they were actively involved in organizing the images for public access, and they began developing a list of favorite images, photographs that captured some of the most important elements of Milwaukee's history and culture. Once they completed cataloging the Oberwise Collection, we had a list of nearly three hundred select images from which to choose. The range of photographs favored by staff and volunteers was nearly as broad as the full range of the Oberwise Collection, including shots of landmark buildings, special events, neighborhoods and many different forms of transportation.

The question of what might be the best way to present even this smaller subset of the Oberwise Collection was a challenging one. The Historical Society staff began by reviewing the images according to the larger categories used to organize the full collection in the Research Library. Criteria including the quality of the image, the importance of the subject and the relationship to Milwaukee's history were taken into consideration as the photographs were winnowed down to the one hundred and fifty included in

this publication. These are drawn principally from the period beginning with the 1940s and extending through the 1960s – the period when Oberwise was most active and when Milwaukee was undergoing considerable change. Hence the title for this collection, *Milwaukee at Mid-Century*. While this comparatively small number of images can do no more than suggest the breadth and depth of the Oberwise Collection, we hope that it will encourage readers to come to the Historical Society and further investigate the treasure trove which this remarkable photographer left behind.

Once the final selections for this book had been made, Richard Hryniewicki, the Historical Society's staff photographer for over thirty years, began the process of converting Oberwise's original slides to a digital format in preparation for printing. He carefully and painstakingly cleaned each image, scanned it and saved it electronically so that it could be reproduced for publication and for future sale through the Historical Society's Research Library and Gift Shop. At the same time, Victor DiCristo of WP&T (Wunderlich Pearson and Tetzlaff) began preparing page layouts and cover illustrations for the publication, donating his services and giving us the benefit of his lifelong experience in the graphic arts. Like the Research Library staff and volunteers, Richard Hryniewicki and Victor DiCristo deserve sincere thanks for the many hours devoted to this project.

While Richard and Vic were preparing the Oberwise photographs for publication, I took on the challenging task of writing the captions to accompany the images. The research conducted by John Angelos and Marilyn Johnson while the Oberwise photos were in their hands proved invaluable in the preparation of the individual descriptions. So too did the resources of the Historical Society's Research Library. While some images still remain a bit mysterious despite Lyle Oberwise's extensive documentation and the hard work of many prior researchers, the majority included here are readily identifiable, even familiar, to Milwaukee's Baby Boomers and at least some of their descendants. My goal in writing the captions was essentially to provide some historic background for each image, to place each subject in its

contemporary context, and – where necessary – to describe the subsequent fate of the building or event depicted. Any success in achieving these goals is the result of generous assistance provided by John Angelos and Marilyn Johnson; Dr. James Marten, Chair of Marquette University's History Department; Sandy Ackerman, past executive director of Historic Milwaukee, Inc.; Lisa Chasco, Assistant Curator of the Society's Research Library; Jerry Zimmerman, Wisconsin State Fair Park historian; and Laurie Albano, unofficial historian of the Milwaukee County Parks. Their critical comments led to more informative – and considerably briefer – captions in virtually every case!

In addition to the many individuals who contributed their time and energy to processing and preparing the Oberwise Collection for publication and public use, thanks are also due representatives of several area foundations that supported the Historical Society's acquisition of the 43,000 images and subsequent publication of this selection of them. Our sincere appreciation goes to Janet Riordan and Daniel Schmidt at The Lynde and Harry Bradley Foundation; to Doris Heiser, Jim Marks and Marybeth Budisch at the Greater Milwaukee Foundation; and to David V. Uihlein, Jr. at the David and Julia Uihlein Charitable Foundation. Without their assistance, the Historical Society would not have been able to preserve this extraordinary collection or make it available to the community.

Finally, while many individuals and organizations have contributed to the preservation and organization of the Lyle Oberwise Collection of historic Milwaukee photographs, our efforts all pale by comparison to the artistry and commitment which Lyle Oberwise demonstrated in creating it. For nearly half a century, this very private man dedicated himself to documenting the public life of his community as it grew and changed. The record he has left provides us all with invaluable information about who we are and where we came from. For this, we are ever in his debt.

Robert T. Teske
Executive Director
Milwaukee County Historical Society

MILWAUKEE

CITYSCAPES

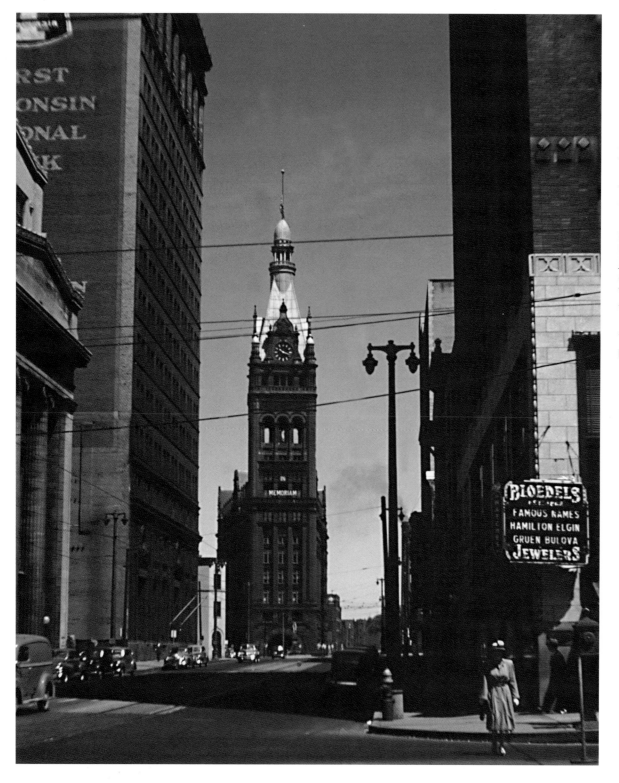

City Hall and North Water Street (1948)* – Designed by H. C. Koch & Co., Milwaukee's City Hall was the third tallest building in the country when it was completed in 1896. Only the Washington Monument and Philadelphia's City Hall surpassed it. The First Wisconsin National Bank Building appears prominently on the left in this view of North Water Street, and Bloedel's Jewelers, long a fixture on the northeast corner of North Water Street and East Wisconsin Avenue, anchors the foreground.

* Date of photograph is indicated in parentheses following the title.

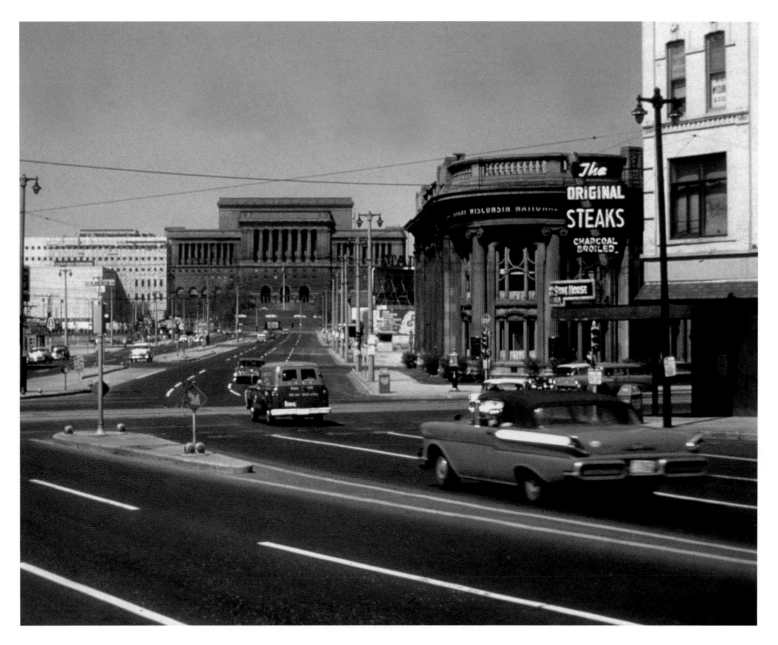

Milwaukee County Courthouse and West Kilbourn Avenue (1963) –
Completed in 1931 and based on a neoclassical design by New York
architect Albert Randolph Ross, the Milwaukee County Courthouse was
intended to mark the western end of a Civic Center extending along Kilbourn
Avenue from City Hall. At this time, West Kilbourn Avenue extended
uninterrupted all the way to the east entrance of the Courthouse.
Several years later, the construction of MacArthur Square, a plaza honoring
General Douglas MacArthur, would separate the Courthouse from
the public buildings to the east.

West Wisconsin Avenue from North Second Street (1946) –

The hustle and bustle of downtown, along with several of Milwaukee's most important buildings, are captured in this view of West Wisconsin Avenue. Central to the image is the Pabst Building, located just east of the Milwaukee River on the north side of Wisconsin Avenue – the site of the log cabin and trading post constructed by Solomon Juneau, one of Milwaukee's founders. The Empire Building just west of the river still sports the large vertical neon sign proclaiming the presence of its principal tenant, the Riverside Theater. On the right, the Red Room Bar's sign juts out over the sidewalk. The Red Room Bar and its counterpart, the Green Room Restaurant, were both located in the Plankinton Arcade building which is now part of the Shops of Grand Avenue.

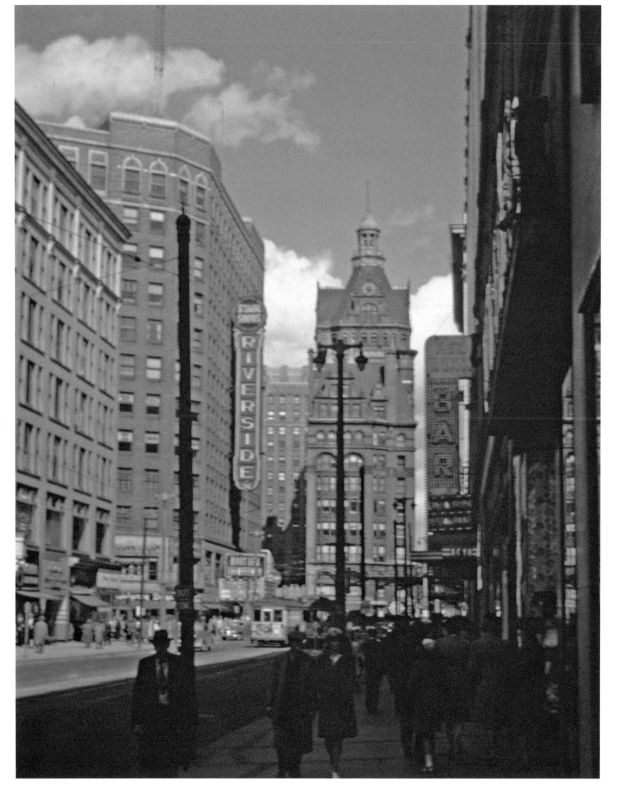

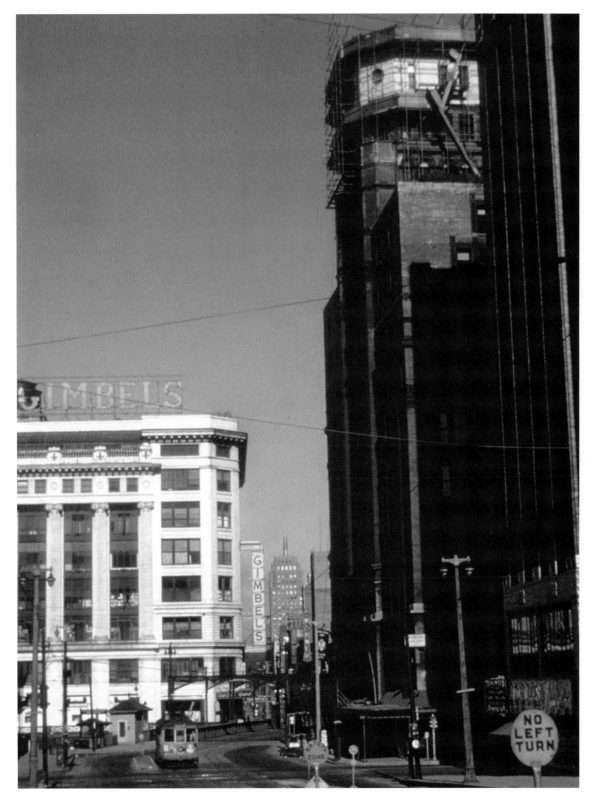

Gimbels Department Store from East Wisconsin Avenue (1948) –
A small storefront on the south side of Grand (now West Wisconsin) Avenue at the Milwaukee River housed the first Gimbels store in the city. For nearly forty years after its 1887 opening, the store grew in piecemeal fashion until it occupied an entire city block. Finally, in 1925, the firm unified the building's massive riverfront façade by adding thirteen four-story columns of glazed white terra cotta. Gimbels Department Store remained one of Milwaukee's foremost retailers for decades, further solidifying its position with the acquisition of Schuster's Department Stores in 1961. But by the early 1980s, despite expansion to suburban shopping malls, Gimbels closed its doors and its downtown location was taken over by Marshall Field's, one of the anchors of the new Grand Avenue Mall. More recently, the building has been converted to accommodate offices, a hotel and smaller retail stores.

Pabst Building (1948) –
The fourteen-story Pabst Building was
built in 1892 on the northwest corner of
Water Street and Wisconsin Street
(now East Wisconsin Avenue). It was
designed by S. S. Beman of Chicago for
Captain Frederick Pabst, owner of the
Pabst Brewing Company. This photo-
graph, taken from the sixth floor of
Gimbels Department Store across the
Milwaukee River, and the preceding
image show the building after the removal
of its four-story tower and octagonal
cupola during a major renovation in
1948. The Pabst Building would remain
standing until 1981, to be replaced in
1989 by the 100 East Building.

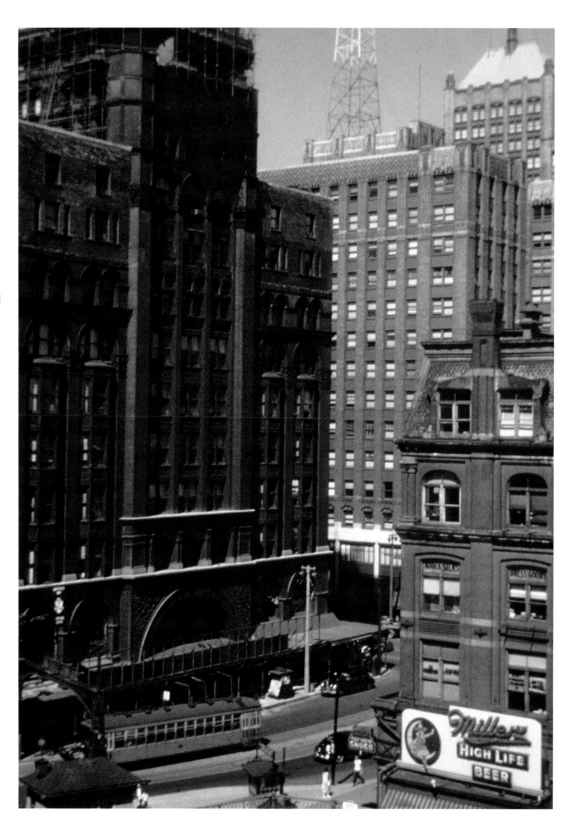

**West Wisconsin Avenue from
North Eleventh Street (1946) –**
The First Methodist Church was founded in 1836 and, in subsequent
years, underwent a number of location and name changes.
The building pictured was constructed in 1908 and served the
congregation until the late 1960s, when it was demolished to make
way for freeway construction. Prior to demolition, the First Methodist
Church merged with Wesley Methodist Church to form the Central
United Methodist Church, now located at 639 North Twenty-fifth
Street. The Milwaukee Public Library and the Milwaukee Tower
appear in the background.

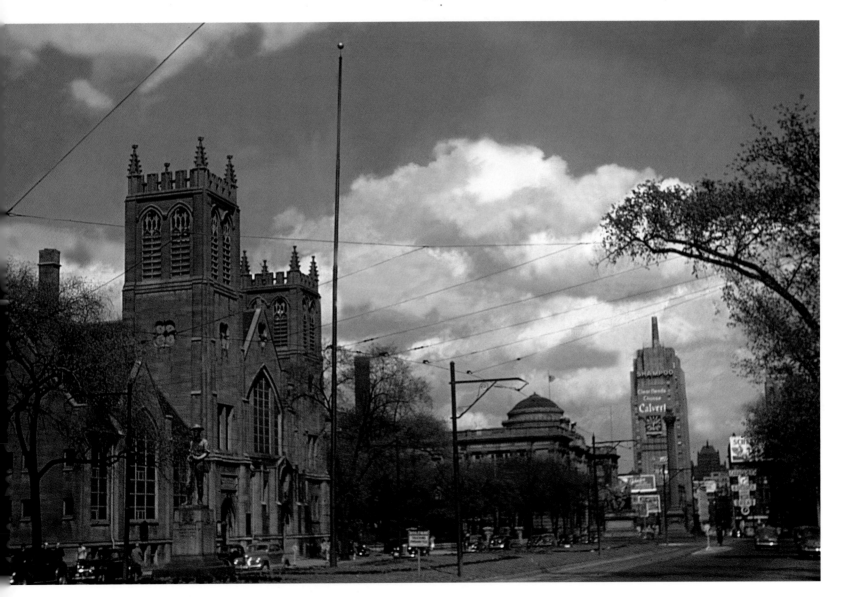

Sunrise over the Court of Honor (1947) –
This atmospheric photograph captures most of the
monuments located on the Court of Honor, a block-long mall
in the middle of West Wisconsin Avenue between
North Ninth and Tenth Streets. Elizabeth Plankinton donated
the first statue, a bronze of George Washington, in 1885. Later
additions included a Spanish-American War memorial,
a column and sphere commemorating a carnival in
1900, and sculptor John Conway's Civil War monument
"The Victorious Charge."

Plantings along West Wisconsin Avenue (1946) –
The median dividing West Wisconsin Avenue between North Tenth and Eleventh Streets was in full bloom during the summer of 1946. Milwaukee was well known during this period for its clean streets, beautiful plantings and exceptional parks. Just beyond Eleventh Street, the Church of the Gesu is visible on the south side of the avenue, while the Tower Hotel – now Marquette University's Carpenter Tower Residence Hall – appears along the north side at the far right.

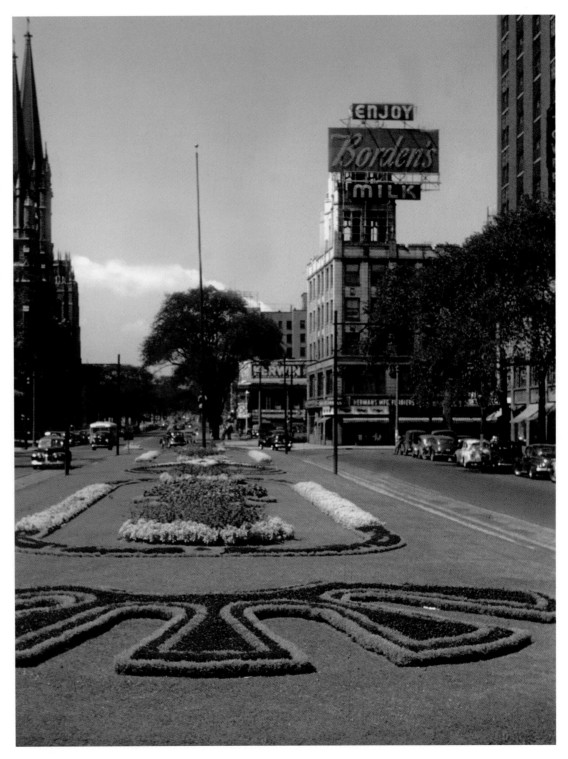

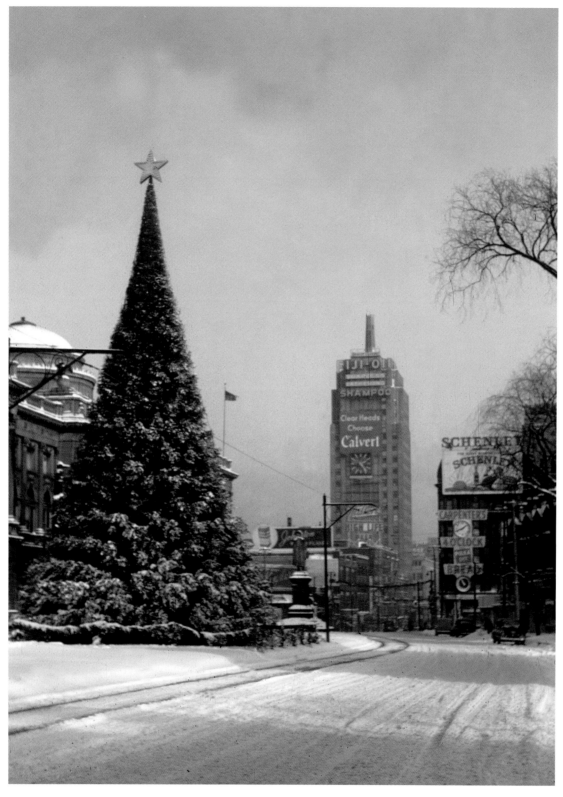

**Community Christmas Tree, West
Wisconsin Avenue (1946, 1949) –**
Beginning in 1913, the City of Milwaukee
annually erected a gigantic Christmas
Tree on the Court of Honor. Initially,
the sixty-foot "tree" consisted of a pole
covered with branches cut from 600
live trees. Wooden scaffolding was
erected around the pole to permit
insertion of the branches. (See inset.)
In later years, the site of the city's
Christmas Tree changed periodically.
It was relocated to the Civic Center
Plaza, to MacArthur Square and most
recently to Red Arrow Park. Only once
since 1913 – in 1999 when Red Arrow
Park's skating rink was under
construction – has the city failed to
erect a Christmas Tree.

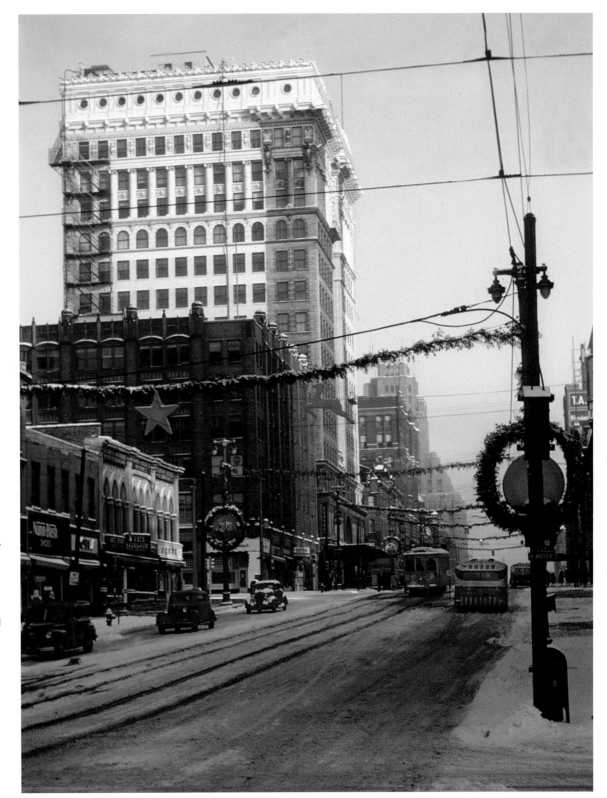

Holiday Decorations on East Wisconsin Avenue (1946) –
The Wells Building at the intersection of East Wisconsin Avenue and North Milwaukee Street dominates this view of downtown's main thoroughfare during a snowy holiday season. The fifteen-story office building was designed by H. C. Koch & Co. and erected in 1901 by pioneer settler Daniel Wells, Jr. At this point in time, the building still retained the elaborate terra cotta cornice and sculptural ornament that would later be removed from its top four floors.

West Mitchell Street from South Seventh Street (1947) –

In addition to documenting Milwaukee's downtown shopping district, Lyle Oberwise recorded the several "satellite" shopping districts surrounding the heart of the city, each of which typically centered around a Schuster's Department Store. Here his camera looks east along West Mitchell Street from about South Seventh Street toward the towers of St. Stanislaus Catholic Church. The Mitchell Street Schuster's store, "where the streetcar bends the corner round," stood several blocks behind and to the left of the photographer.

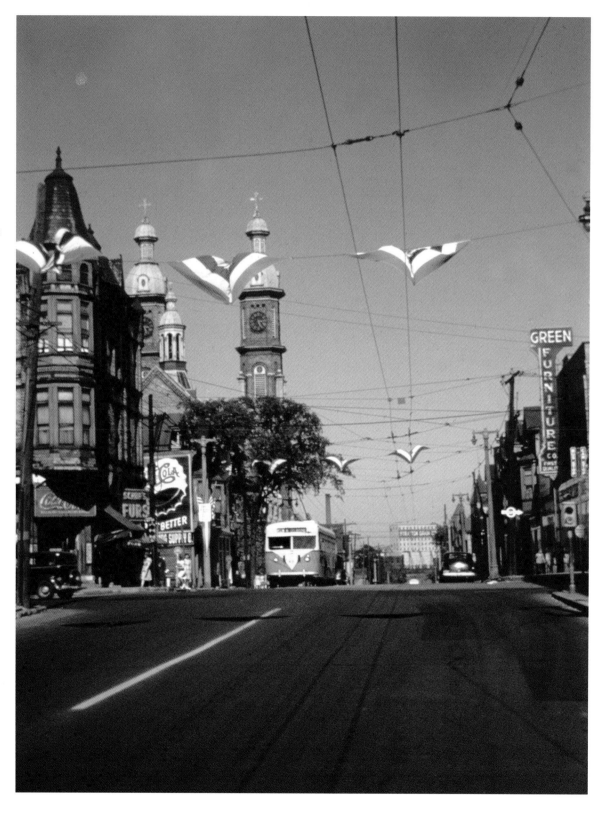

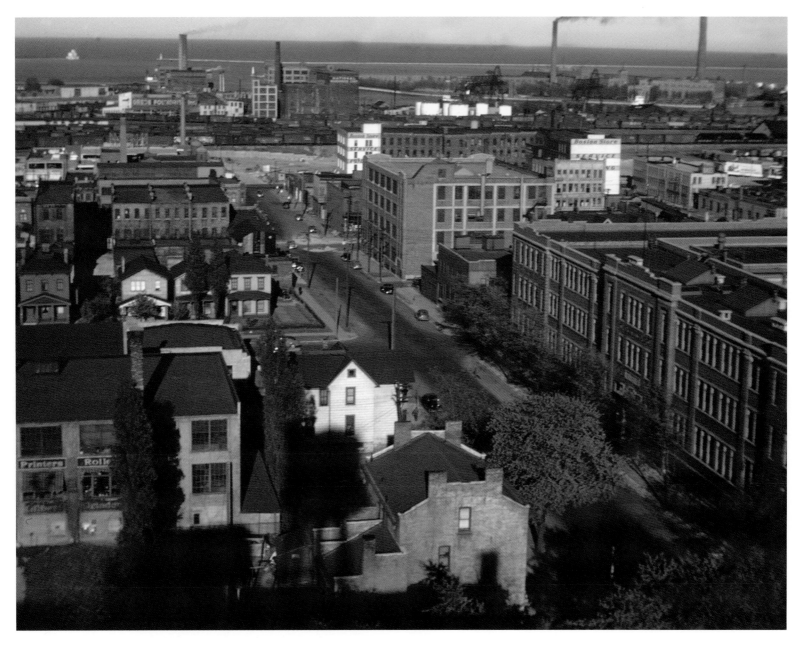

West Florida Avenue from South Fourth Street (1948) –
Following his service in the U.S. Army during World War II,
Lyle Oberwise worked as a machine operator for Milprint Packaging
until 1952. This view of Florida Avenue looking east over Walker's
Point toward the Kinnickinnic River and Lake Michigan was taken
from the Milprint building, located at 431 W. Florida Avenue.
Boys' Tech High School appears prominently in the foreground.

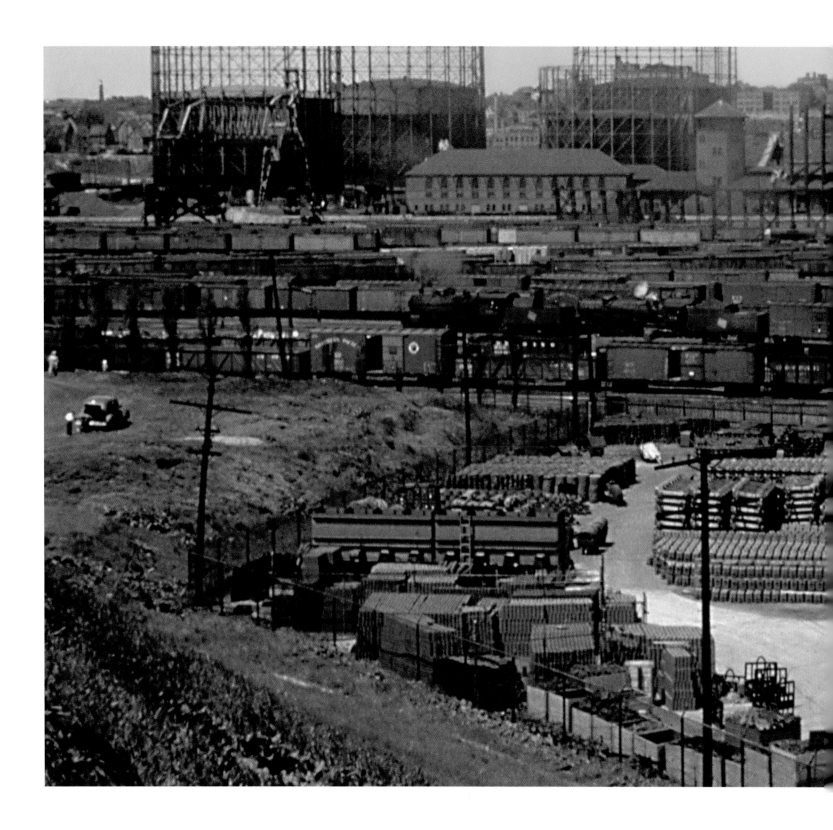

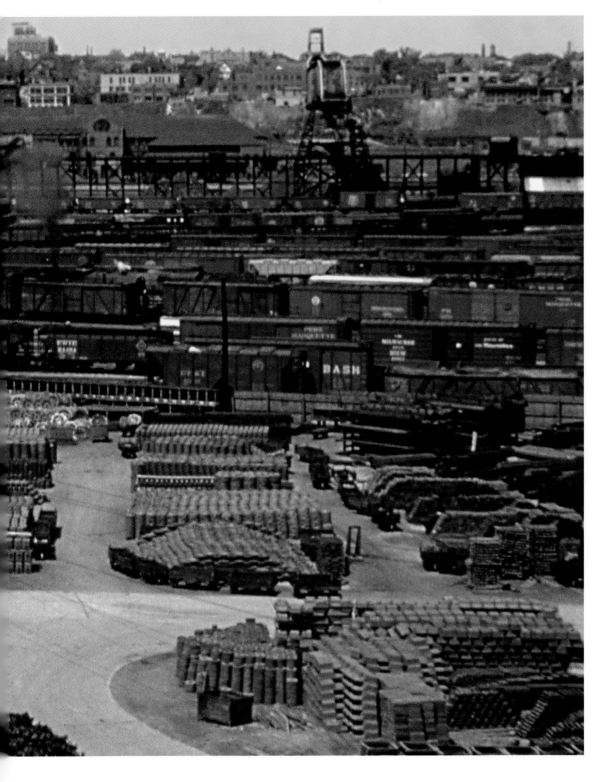

Menomonee River Valley (1946) –
Long the industrial center of the
City of Milwaukee, the Menomonee River
Valley was home to tanneries,
railroads and heavy equipment manufac-
turers. The density of the commercial and
industrial use of the valley following World
War II is clearly documented
by this image looking directly north from
the valley's southern edge. The red
brick warehouses just to the right of the
natural gas storage tanks are still visible
today from I-94 at North Twenty-second
Street. However, much of the rest
of the Menomonee Valley is being
converted to recreational and even
environmental use with the construction
of Potawatomi Bingo and Casino,
Marquette University's Valley Fields, Miller
Park, the Hank Aaron Trail and
the new Harley-Davidson Museum.

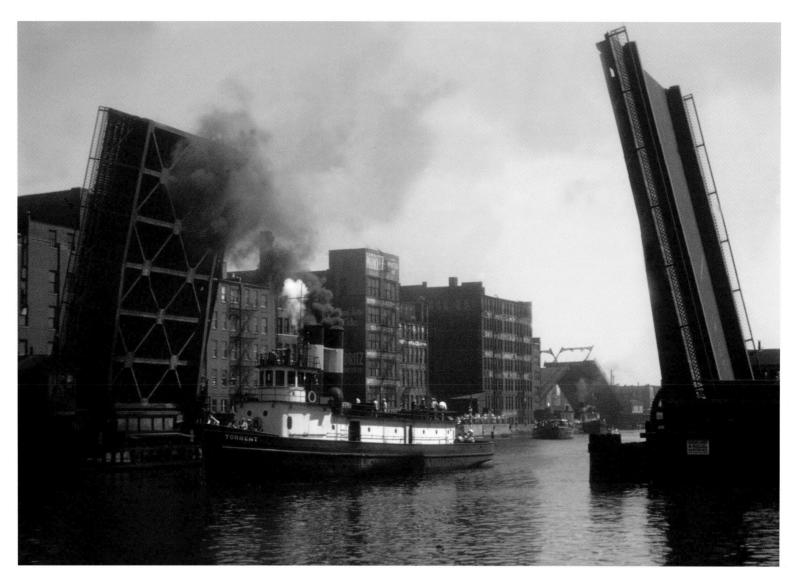

**Fireboat *Torrent*
on the Milwaukee River (1949) –**
Like the Menomonee River, the Milwaukee River
continued to be an important commercial
waterway well into the middle of the twentieth
century. Ships carrying coal to the Commerce
Street power plant and grain to the Pabst
grain elevators still navigated up the river almost
as far as the North Avenue dam. Here the
Milwaukee Fire Department's fireboat *Torrent*
passes below the St. Paul Avenue bridge,
while the Water Street bridge remains open
in the background.

30

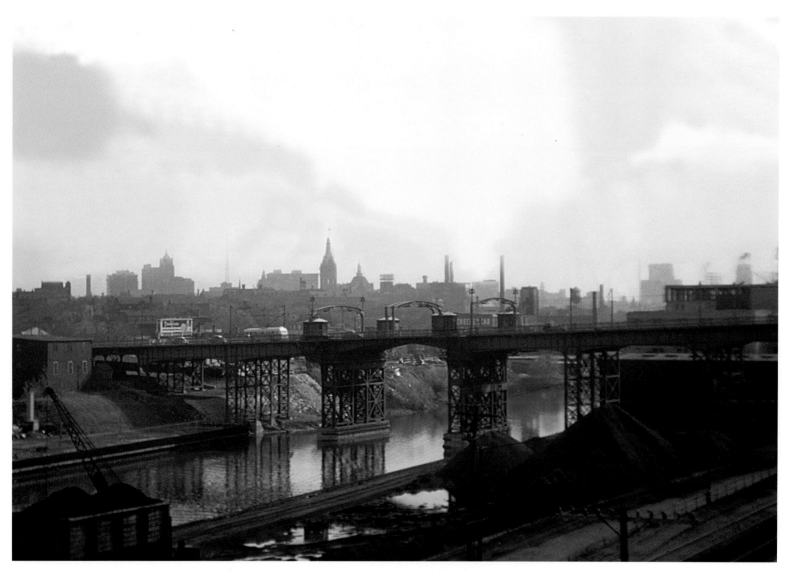

**Holton Street Viaduct
over the Milwaukee River (1948) –**
The Holton Street viaduct was constructed in 1926
to replace the original double-leaf "jackknife"
bascule bridge that had been built on the site by
Wisconsin Bridge and Iron Company in 1894.
The river's high banks at Holton Street placed the
deck of the viaduct some sixty feet above
the water. Visible below the bridge are coal piles
and railroad tracks for the city's "Beer Line" –
the rail spur that served Milwaukee's downtown
breweries. Much of the area is now
devoted to condominium construction.

**Marc Plaza and Clark Building
at Sunset (1983) –**
The late afternoon sunlight from the
southwest illuminates the Clark Building at
633 West Wisconsin Avenue and the
Marc Plaza Hotel just one block to the east.
The Clark Building was constructed in 1964,
and the Marc Plaza was the name given to
the Schroeder Hotel when it was owned and
operated by the Marcus Corporation from
1974 until 1995.

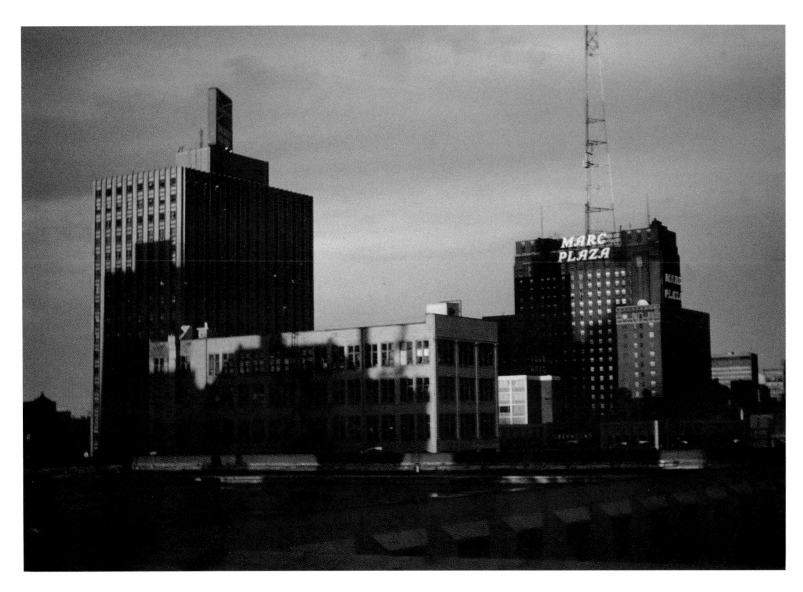

MILWAUKEE

PUBLIC BUILDINGS

**St. John the Evangelist
Cathedral (1946) –**
Milwaukee's first bishop, John Martin Henni,
established the completion of St. John's
Cathedral as his primary objective upon taking
office in 1843. The construction of the church
in 1847 fulfilled Henni's goal. Designed by
Victor Schulte, St. John's was originally
much shorter than the present building and
had a different tower with a baroque
roof. Deterioration of the tower prompted its
removal and replacement in 1892 with the
present design developed by Milwaukee architect
George B. Ferry of the firm Ferry & Clas.
Recently, St. John's underwent extensive
renovations that unified the exterior of the
cathedral and surrounding buildings, and
that substantially altered the interior.

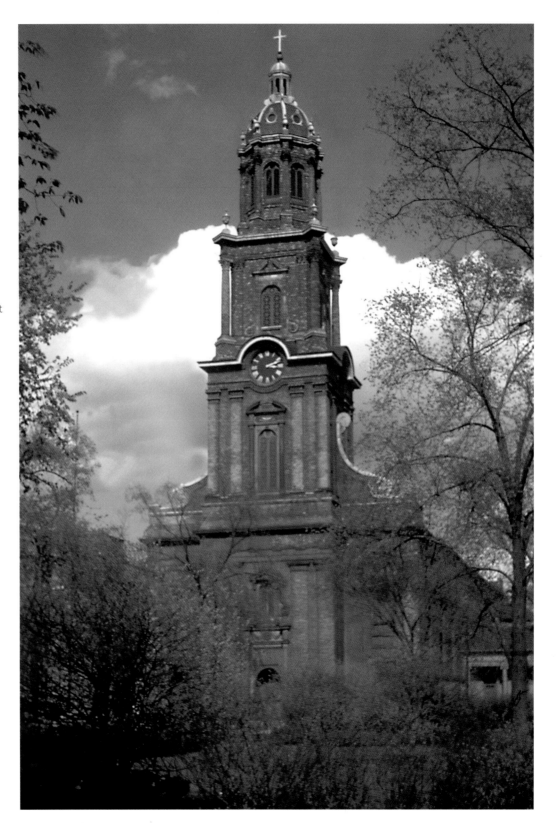

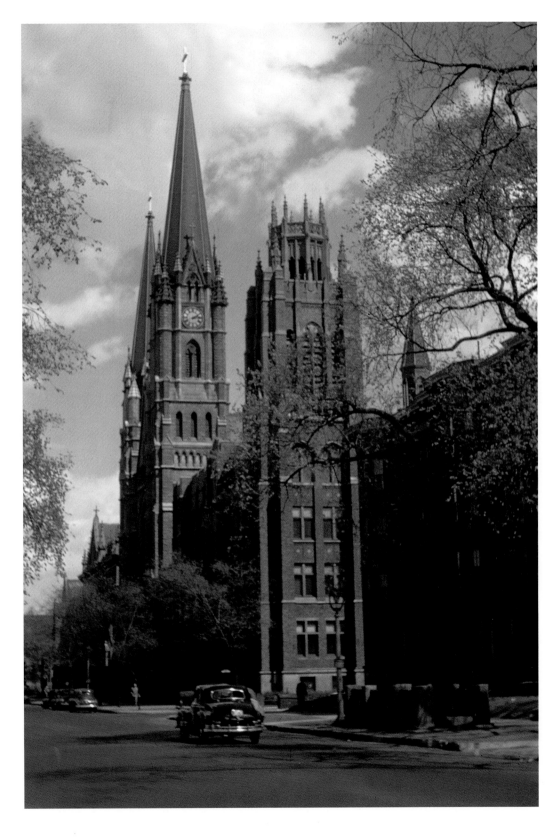

Church of the Gesu and Science Hall (1946) –
The Church of the Gesu was the first structure along Grand (now West Wisconsin) Avenue to be commissioned by Milwaukee's Jesuits. It was named after the church in Rome where St. Ignatius Loyola, the founder of the Society of Jesus, is buried. Designed by the architectural firm of H. C. Koch & Co. and dedicated in 1894, the building closely followed French Gothic precedents. It replaced both St. Gall's Church on Second and Sycamore (now Michigan) Streets and Holy Name of Jesus Church on Tenth and Tamarack (now State) Streets. Science Hall, just west of Gesu, was completed during the 1920s to provide much-needed classroom and laboratory space for Marquette University students.

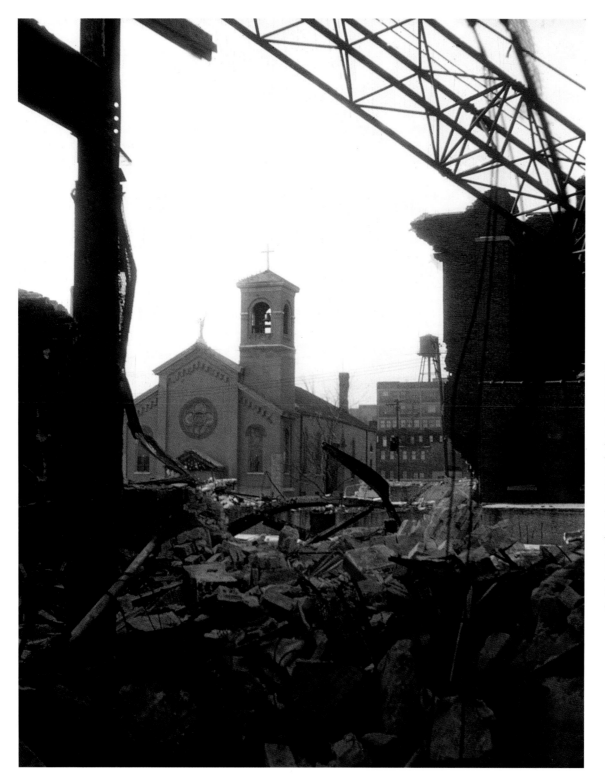

**Our Lady of Pompeii
Catholic Church (1959) –**
Framed by the demolition of a nearby
building, *Madonna di Pompeii* was the parish
church for Milwaukee's Third Ward Italian
community. Designed by Erhard Brielmaier,
the architect of St. Josaphat's Basilica,
the "little pink church" was dedicated in 1905.
It was the focal point for numerous
festivals marking the religious calendar of the
local Italian community. The church
was razed in 1967 to permit freeway
construction, prompting early objections to
the destruction of the city's historic
and cultural resources. Today the former
location of Our Lady of Pompeii Church,
419 North Jackson Street, is indicated
by a commemorative marker beneath the
elevated I-794 freeway.

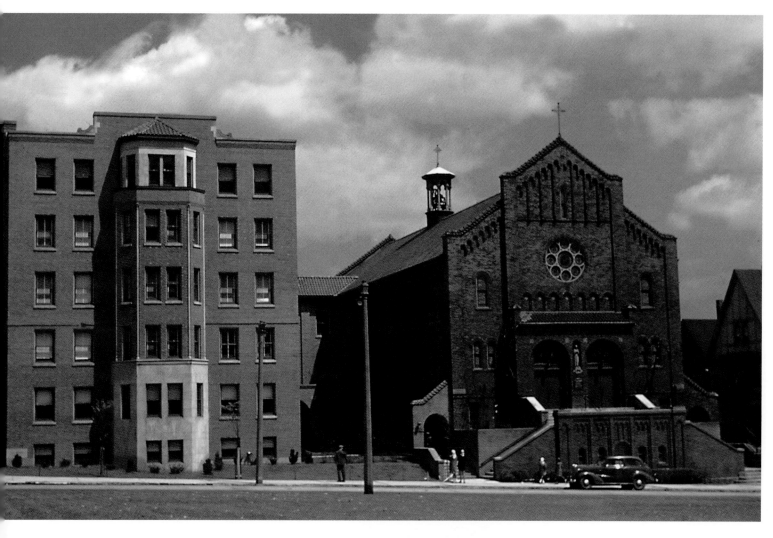

**St. Anthony's Hospital and
St. Benedict the Moor Church (1947) –**
St. Benedict the Moor Mission was established in Milwaukee in 1908
as one of a number of "colored missions" created by the Catholic Church
for African-Americans migrating to the North. The church shown
in this photograph was constructed on Tamarack (now West State) Street
between Ninth and Tenth Streets in the early 1920s. St. Anthony's Hospital,
just west of the church, opened in 1931 as an outgrowth of St. Benedict's
school infirmary. The hospital was among the earliest to employ
African-American doctors and nurses and to serve both the black and white
communities in the downtown area. While St. Benedict the Moor Church
continues to minister to residents of the central city, St. Anthony's was
converted into the Downtown Community Correctional Center in 1987.

Wesley Methodist Church (1949) –
Established in 1883, Wesley Methodist Church originally
occupied a building on Washington Avenue. Due to increases in
membership, a larger church was required within twenty years.
This building was dedicated at North Twenty-fifth Street and Grand
(now West Wisconsin) Avenue in 1905. Following a merger with
the First Methodist Church in the 1960s, the combined congregations
worshipped in the Wesley Methodist Church building for more than a
decade. However, this facility was demolished in 1981 and replaced
by the new Central United Methodist Church on the same site.

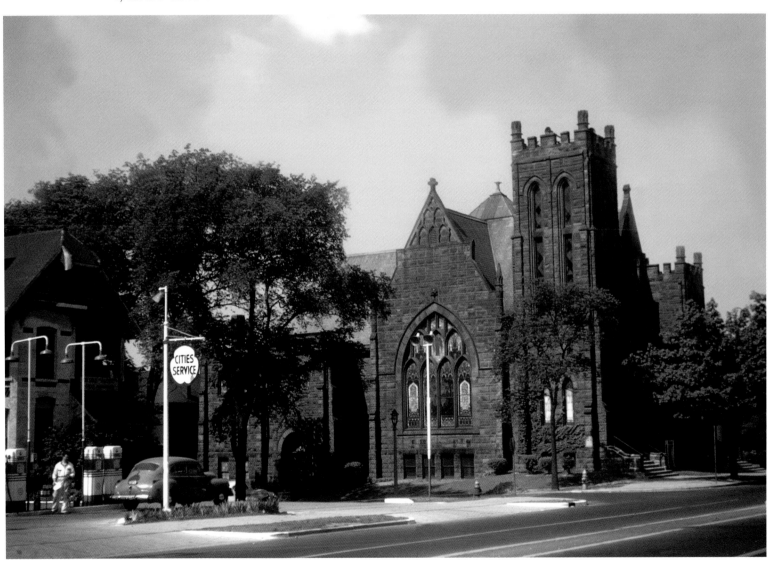

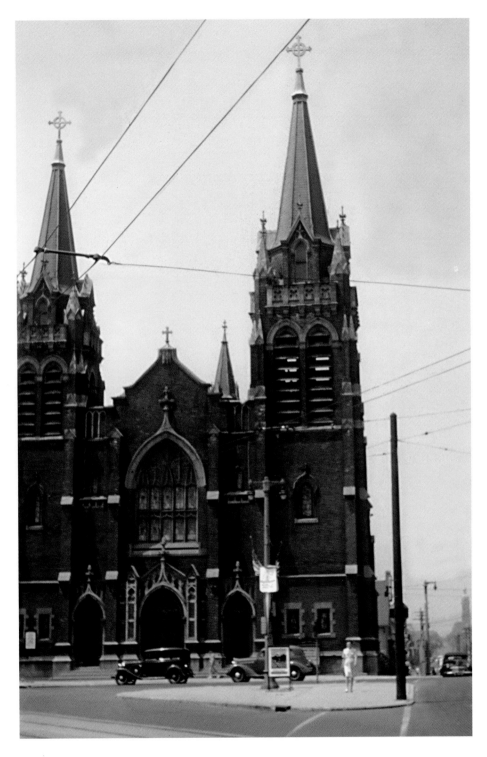

St. Jacobi Evangelical Lutheran Church (1946) –

The St. Jacobi congregation was organized in 1873. A full city block at Eighth Avenue (now South Thirteenth Street) and Mitchell Street was purchased that same year for construction of a church and school. The Gothic Revival church pictured here – the second St. Jacobi Lutheran Church – was built in 1905-1906 according to plans prepared by Milwaukee architect Otto C. Uehling. Because the congregation was originally of German heritage, services were conducted exclusively in that language until 1918. Subsequently, English was introduced, but German language services were not completely discontinued until 1971. The church on West Mitchell Street was demolished in 1977, and a new church was dedicated in Greenfield in 1979.

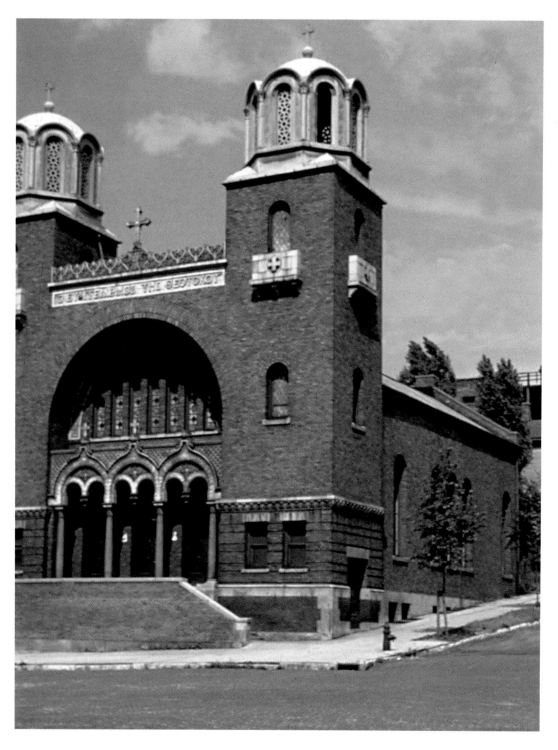

Annunciation Greek Orthodox Church (1946) – Annunciation Greek Orthodox Church was founded in 1904 by male immigrants who had come to the United States to work and send money back to their families in Greece. By 1912 the congregation saved $8,000 and construction began on the church shown here, located at Broadway and Knapp Streets. In 1952 the congregation purchased twenty acres of land in Wauwatosa for a new facility. They commissioned Wisconsin architect Frank Lloyd Wright to design their new sanctuary, which opened on North Ninety-first and West Congress Streets in 1961.

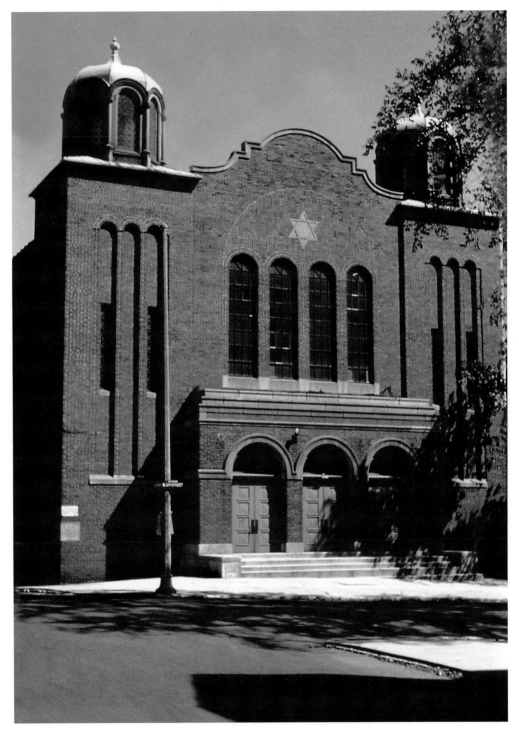

Congregation Anshai Lebowitz (1946) –
Organized in 1906 by a group of Russian
immigrants from the city of Lubavich,
Congregation Anshai Lebowitz was first
located on Eighth and Walnut Streets.
A new synagogue, pictured here, was
constructed at Eleventh and Vine Streets in
1925. The new facility included special
quarters for the Milwaukee Talmud Torah.
Congregation Anshai Lebowitz relocated once
again during the 1950s, moving to North
Fifty-second and West Burleigh Streets.
In 1998, the congregation moved to Mequon.

Marquette College (1947) –
Constructed in 1881 on the northwest corner of Tenth and Tamarack (now State) Streets overlooking downtown Milwaukee, this modest four-story building originally housed both Marquette Academy and Marquette College. Its location spawned the nickname "Hilltoppers," which Marquette University teams used for many years and which Marquette University High School teams continue to use to this day. In 1925 after Marquette University and Marquette High moved to their present locations, this structure became part of St. Benedict the Moor School, a boarding school that served African-Americans from throughout the Midwest. It was demolished in the 1960s to accommodate freeway construction.

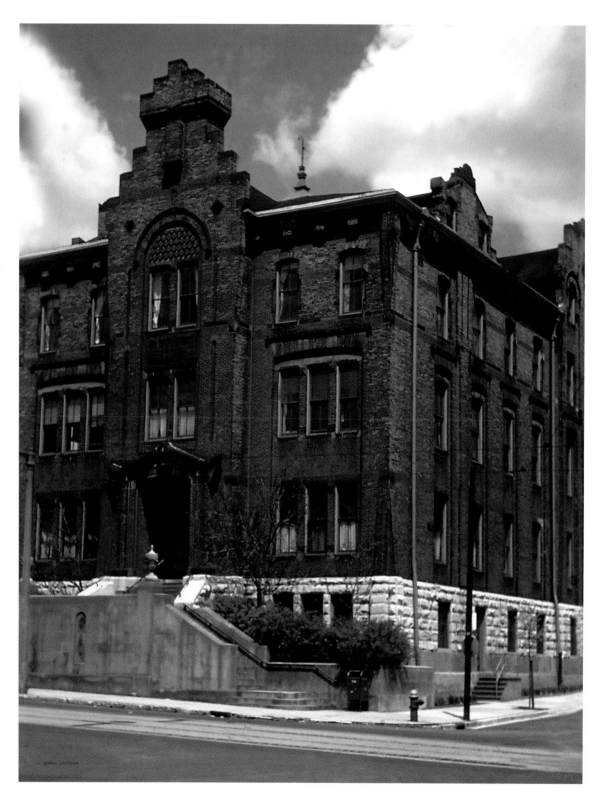

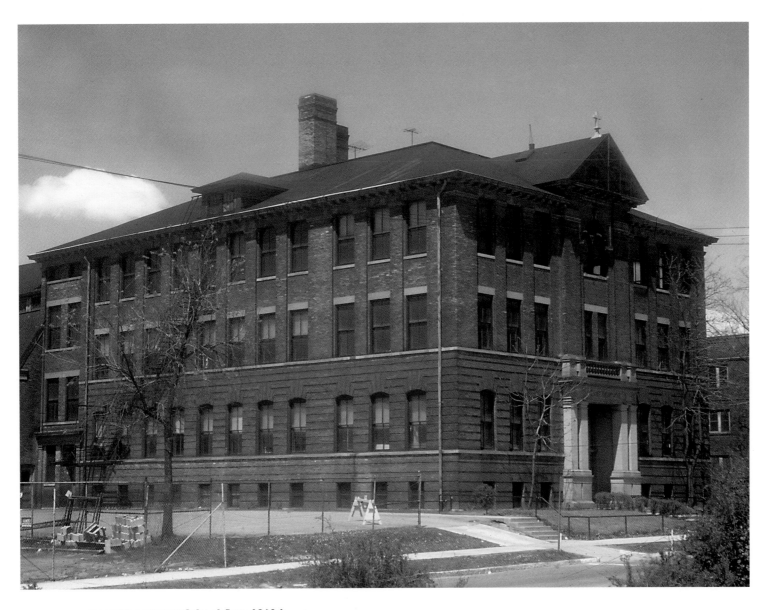

Gesu Elementary School (late 1960s) –
Five years after the dedication of the Church of the Gesu
in 1894, a large parish school was built to the southwest of the church
building. The school, which faced Thirteenth Street, originally
served students from the Fourth Ward, from Tory Hill and from
wealthy Catholic families whose residences lined Grand Avenue.
The building was subsequently demolished about 1968 to
make way for expansion of the Marquette University campus.

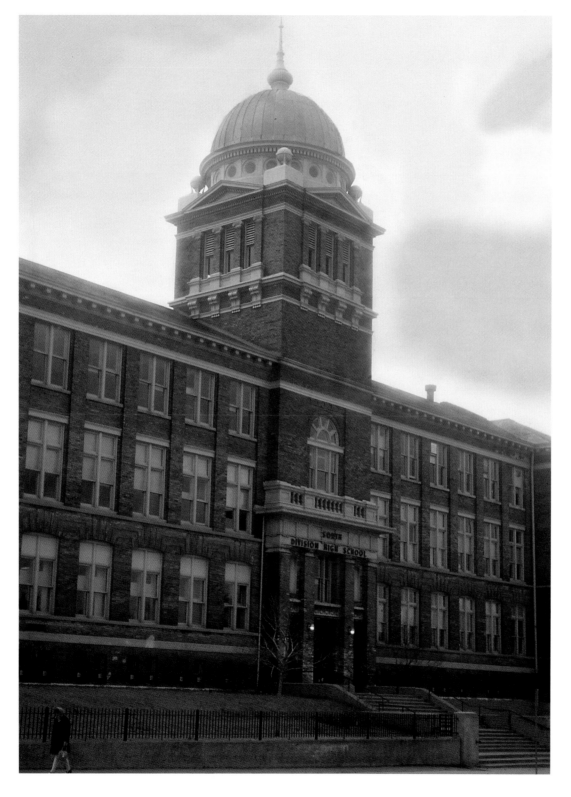

**South Division
High School (c. 1972) –**
Designed by Milwaukee architect
Didrik C. Ottesen and constructed in
1898-1899, South Division High School
was located at Eighth Avenue
(now South Thirteenth Street) and
Lapham Boulevard. The building was
expanded three times, in 1911,
1916 and 1951, until it extended a full
city block and had as its central
focus a four-story tower with a copper
dome. The dome was removed
in 1978 when the original building was
demolished and a new facility
was constructed in its place. Recently,
the dome was installed atop
Bluemel's Florist and Garden Service
on West Loomis Road.

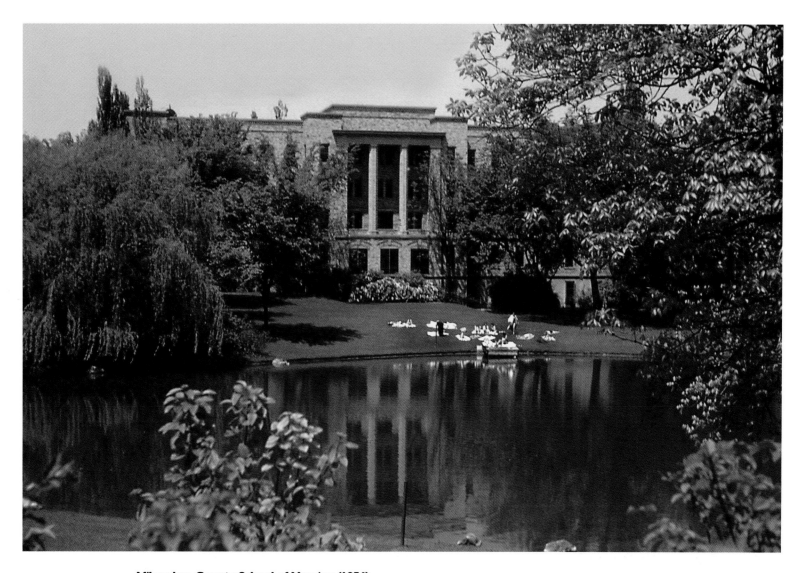

Milwaukee County School of Nursing (1956) –
In 1887, Dr. M. E. Connell, the superintendent of Milwaukee County Hospital, and his wife, Dr. Anna Gregory Connell, established a class for the "instruction and training of nurses for service." The first class of thirteen students began studies on the County Grounds in 1888. In 1932, this building overlooking the "duck pond" along Wisconsin Avenue was constructed to provide classrooms, laboratories, and residential facilities for the School of Nursing. It was demolished in the 1990s to make way for further construction at the Milwaukee Regional Medical Center.

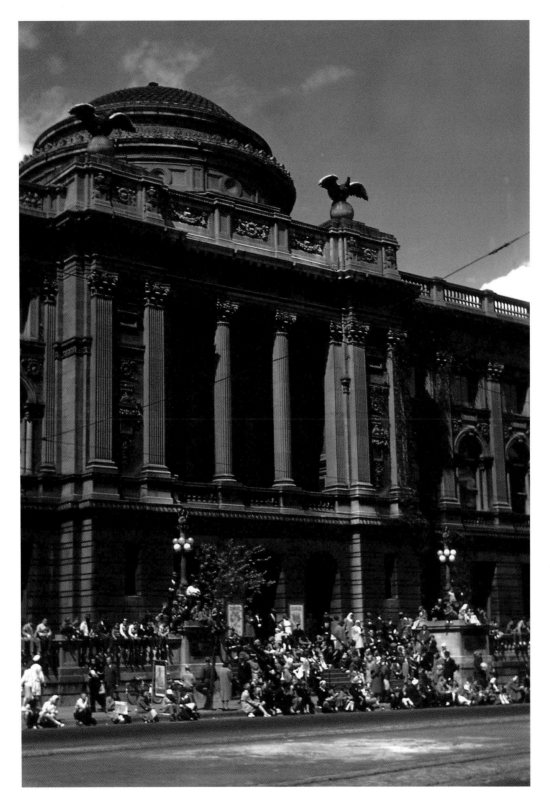

Milwaukee Public Library (1947) –
The product of a national architectural
competition won by the local firm
of Ferry & Clas, the Milwaukee Public Library
was completed in 1897. One of the earliest
and finest examples of the classical revival
style in Milwaukee, the building housed both the
Public Library and the Public Museum
until the latter constructed new quarters
directly across West Wells Street in 1964.
The location of the library on Milwaukee's
principal parade route – West Wisconsin
Avenue – is evident from this photograph.

Turner Hall (1946) –
The Milwaukee Turners Gymnastic
and Fraternal Society was organized in
1853, only seven years after the founding of
the City of Milwaukee. While there
were a number of Turner halls in Milwaukee
over the years, the building constructed in
1882–1883 on Fourth Street was the
largest. Designed by Henry C. Koch, the
Richardsonian Romanesque building
cost $80,000. A great ballroom and theater
stage on the second floor were severely
damaged by fire in 1933 and have only
recently been returned to use following
extensive restoration.

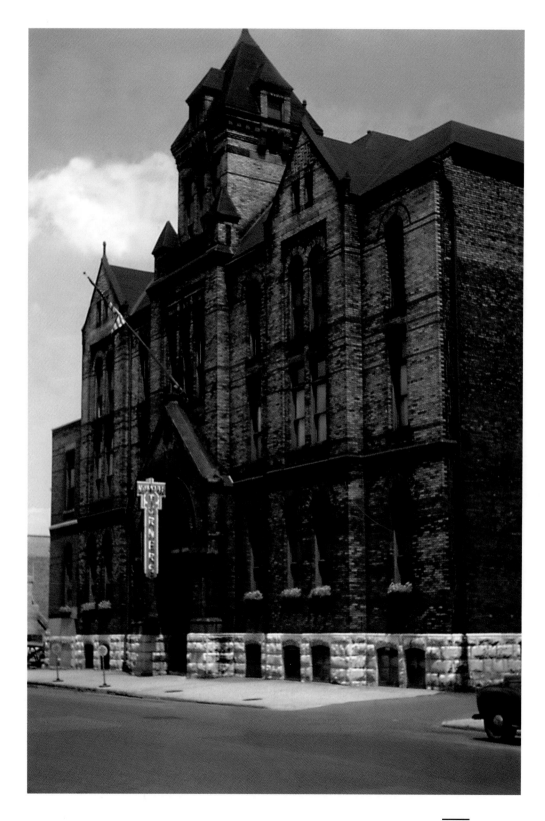

Milwaukee Auditorium (1949) –
Constructed in 1905 according to plans drawn by Ferry & Clas,
the Milwaukee Auditorium replaced the city's Victorian Exposition Building,
which stood on the same site from 1881 until it was destroyed by fire in 1905.
After construction of the Arena just to the east of the Auditorium began in
1945, the West Kilbourn Avenue entrance to the building replaced the North
Fifth Street entrance as the main point of access. In 2003, the Auditorium was
converted into the 5,500-seat Milwaukee Theatre.

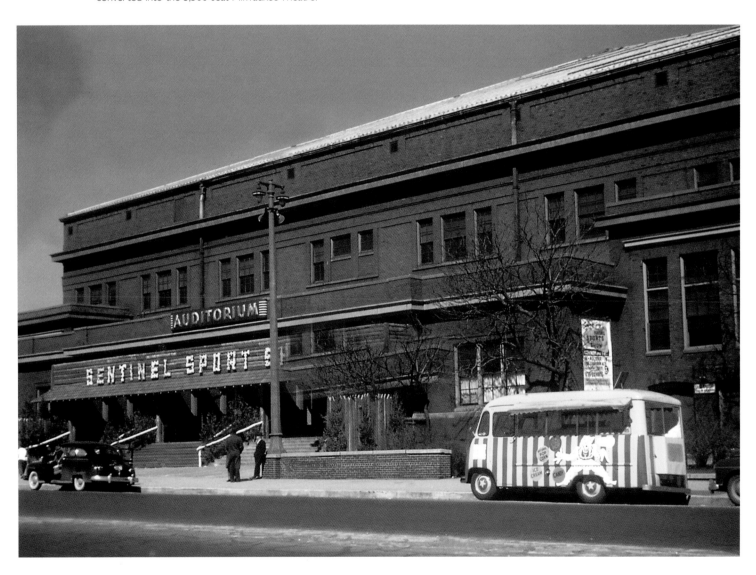

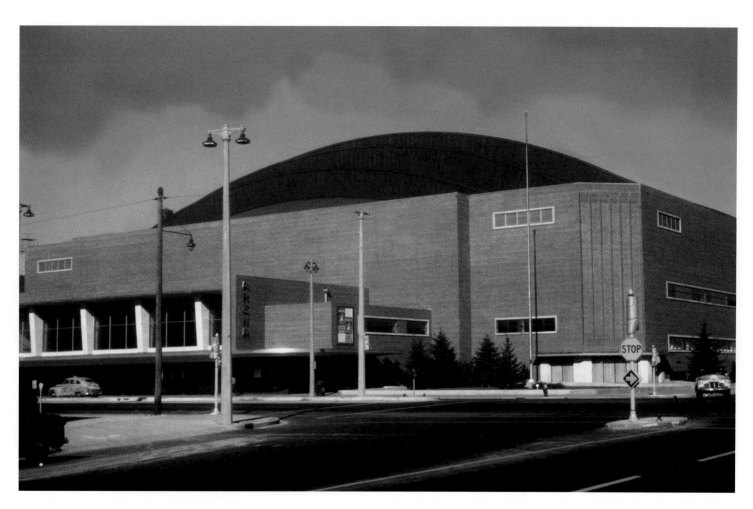

Milwaukee Arena (1950) –
Designed by Milwaukee architects Eschweiler & Eschweiler, the Milwaukee Arena
opened in 1950 after approximately five years of construction. One of the
first facilities designed to meet the needs of broadcast television, the Arena was home
to the National Basketball Association's Milwaukee Hawks ('1951-1955) and Milwaukee
Bucks (1968 1988), the Milwaukee Admirals of the International
Hockey League (1984-1987), and the Marquette Warriors (1974-1989).
Many of these teams moved to the Bradley Center upon its completion in 1988.
However, the Arena is now home to the Milwaukee Wave Soccer team and the
University of Wisconsin - Milwaukee Panthers men's basketball team.

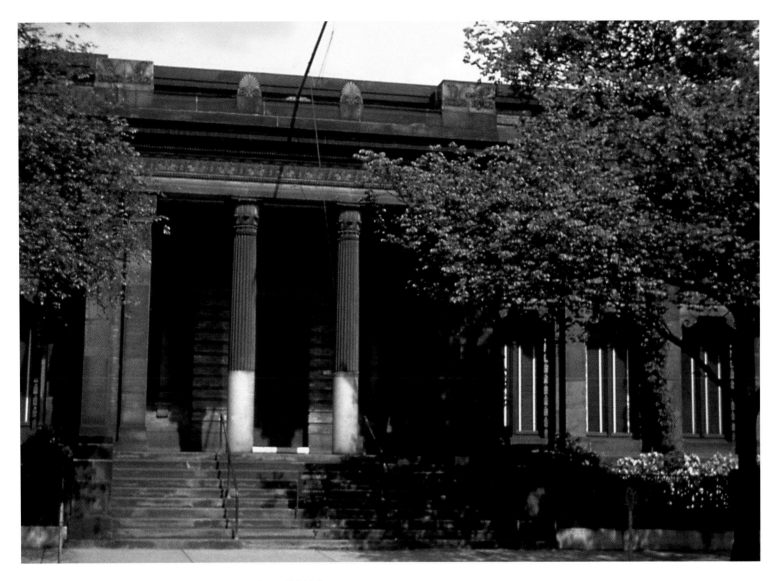

Layton Gallery of Art (1960s) –
The classically inspired Layton Gallery of Art, constructed
in 1888 on Jefferson Street between Mason and Wells Streets,
provided a spacious home for the extensive art collection
of Frederick Layton. Layton came to Milwaukee from
England in 1843 with his father John and opened a successful meat
packing business. In 1957, the Layton Gallery and the Milwaukee
Art Institute moved into the Milwaukee County War Memorial
Center. The Layton Gallery building was subsequently razed in the
interest of urban renewal, and in 1975 the 770 Jefferson Building
was constructed on its site.

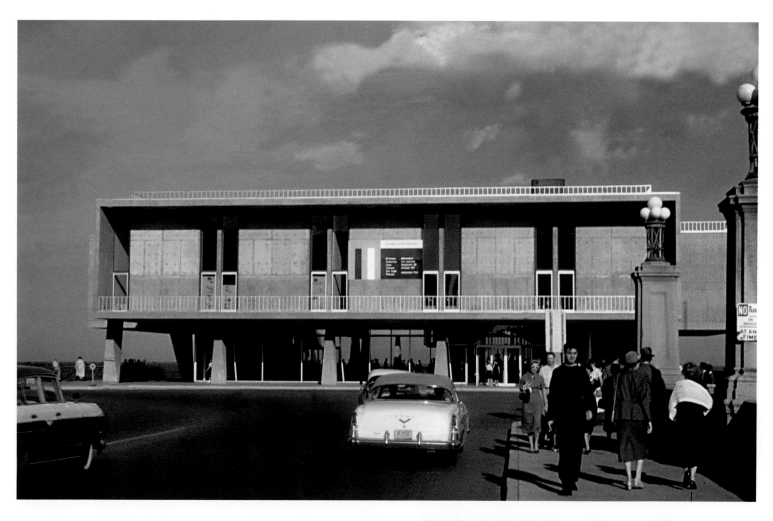

Milwaukee County War Memorial Center (1958) –
Conceived as a living memorial to Milwaukee servicemen
who gave their lives in World War II and the Korean War, the
Milwaukee County War Memorial Center was designed by Finnish
architect Eero Saarinen and still stands as the city's earliest
example of modern architecture. The War Memorial Center
opened in 1957, and the western façade is shown here
before the addition in 1959 of Wisconsin artist Edmund
Lewandowski's tiled mosaic which uses Roman numerals to
depict the dates of World War II and the Korean War.

Milwaukee County General Hospital (1948) –
Constructed in 1927 on the Milwaukee County Grounds at a cost
of $1.8 million, the new County General Hospital replaced original buildings
dating back to 1880. The new facility nearly doubled the number of
beds previously available, accommodating 650 patients. However, by 1936,
Works Progress Administration support was required to refurbish
the old buildings in order to add capacity for an additional 400 patients.
Several years after being renamed in honor of County Executive John L. Doyne,
the hospital closed in 1995. The buildings and programs were sold to
Froedtert Memorial Lutheran Hospital, and the structures were demolished
in 2001 to accommodate new construction at the Milwaukee Regional
Medical Center.

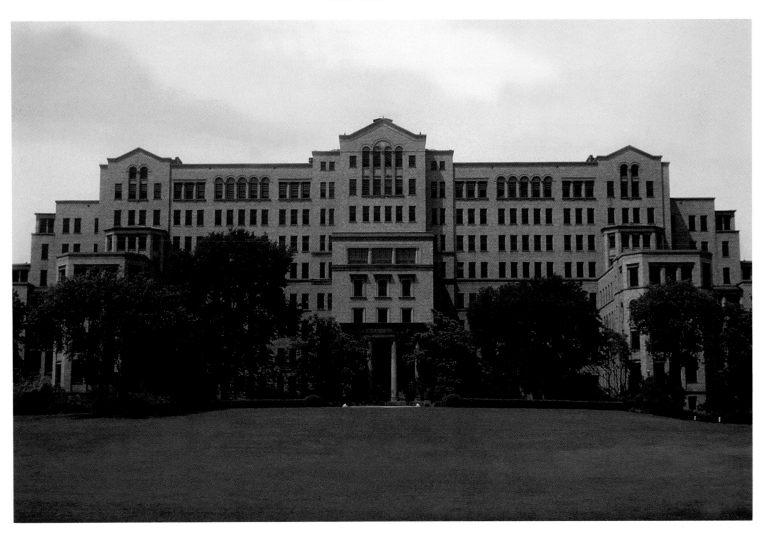

Lakeview Hospital (1952) –

Lakeview Hospital was organized in 1944 as a seventeen bed osteopathic
hospital in a converted residence at 1749 North Prospect Avenue.
A remodeling program in the 1950s increased the capacity to forty beds.
In 1964, Lakeview acquired land at 10010 West Bluemound Road in Wauwatosa
and began construction of a new general hospital with facilities for one
hundred patients, a modern outpatient department, x-ray and laboratory
facilities and an emergency room. The hospital relocated to its new quarters
just east of St. Camillus Hospital in September, 1966. The Prospect Avenue
property was subsequently converted into a nursing home. The Wisconsin
Heart Hospital now occupies the West Bluemound Road site
where Lakeview Hospital once stood.

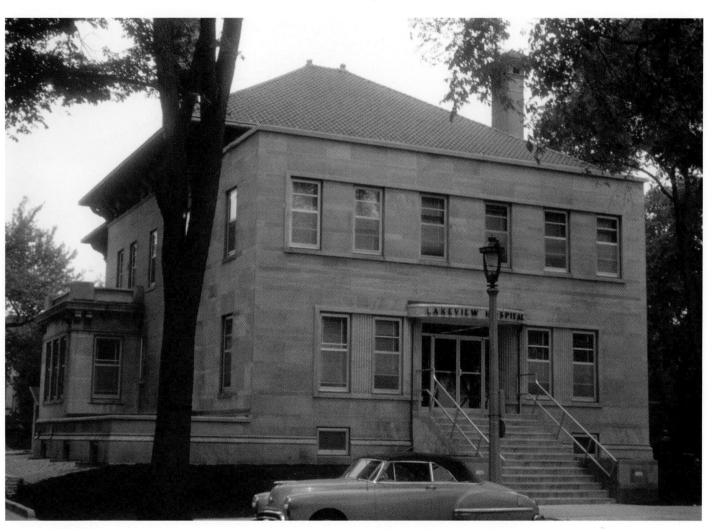

Milwaukee Hospital (1945) –
Milwaukee Hospital was founded
in 1863 by Rev. Dr. William Alfred
Passavant, one of the most influential
Lutheran clergymen of his day. Located
on "Hospital Hill" at Twenty-second Street
and Kilbourn Avenue, the "Milwaukie
Infirmary," as it was originally called, was
the first Protestant hospital west of
Pittsburgh. Theodore Roosevelt was
treated at Milwaukee Hospital following an
unsuccessful assassination attempt in
Milwaukee in 1912. In order to avoid
confusion with other facilities, Milwaukee
Hospital changed its name to Lutheran
Hospital in 1966. In 1980, the hospital
merged with Deaconess Hospital to
form Good Samaritan Medical Center.
Following subsequent mergers with
St. Luke's and Mount Sinai, the Kilbourn
Avenue campus was closed. Part of the
facility now houses the Milwaukee
Academy of Science, while another part
has been converted to apartments.

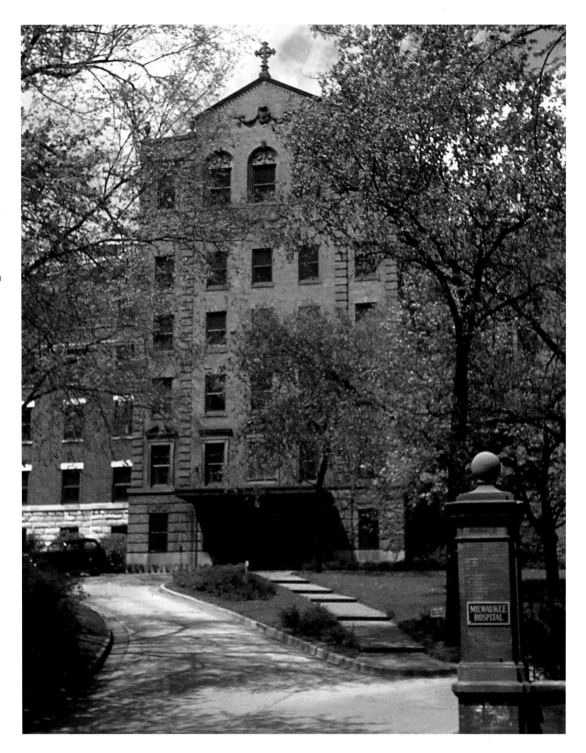

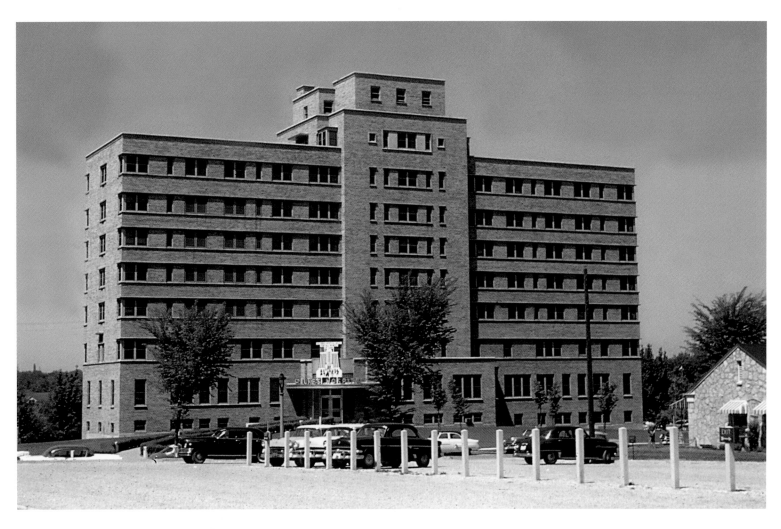

St. Luke's Hospital (1954) –

St. Luke's Hospital officially came into existence in 1928 when the Milwaukee
Federation of Lutheran Laymen agreed to assume responsibility for operating the South Side's
only hospital facility, then located on the northeast corner of South Third and West Madison
Streets. Seven years later, the St. Luke's Hospital Association was incorporated under
a nonprofit charter. In the early 1950s, with no room for expansion on Madison Street,
St. Luke's purchased property at South Twenty-ninth Street and West Oklahoma
Avenue and constructed the new seven-story, 180-bed facility pictured here.
St. Luke's later merged with Good Samaritan Medical Center in 1984 to form St. Luke's
Samaritan Health Care. Following a 1987 merger with Mount Sinai Medical Center,
St. Luke's Samaritan Health Care became Aurora Health Care.

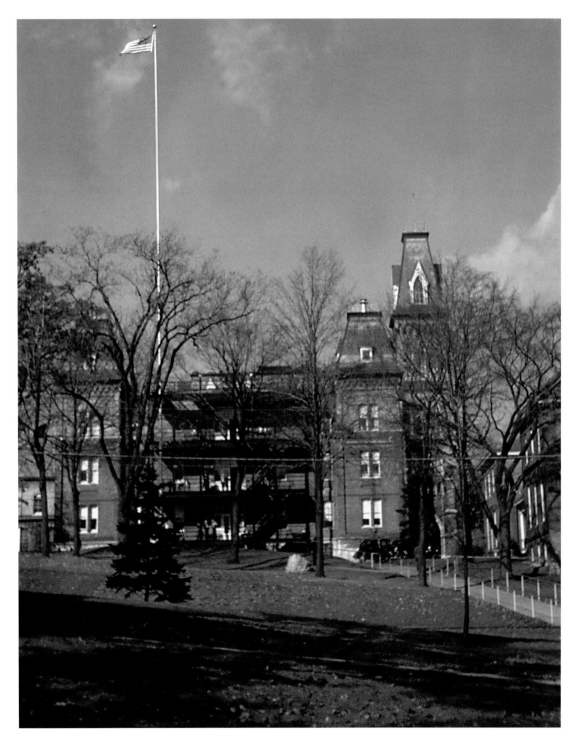

National Soldiers Home (1946) –
Milwaukee architect Edward Townsend Mix designed the main administration building of the National Soldiers Home at Wood in the Gothic Revival style popular in the 1860s. Milwaukee was one of four sites selected for a National Home for Disabled Volunteer Soldiers following their creation by an Act of Congress just after the Civil War. The others were Togus, Maine; Hampton, Virginia; and Dayton, Ohio. The main building is still in use today as part of a complex which houses the Clement J. Zablocki VA Medical Center, the Veterans' Affairs Department Regional Office and the Wood National Cemetery.

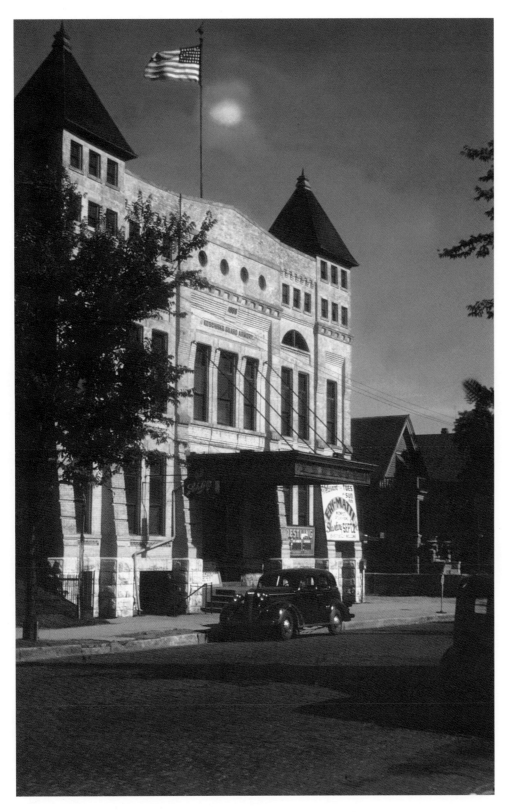

South Side Armory (1948) –
One of many buildings in Milwaukee
constructed by Works Progress
Administration laborers during the
Depression, the South Side Armory
originally served a primarily military
purpose. However, in later years
the armory came to be known as
a popular venue for professional wrestling,
dances and other social activities. Located
at 1620 South Sixth Street, the South Side
Armory was demolished about 1964.

Alonzo Cudworth American Legion Post #23 (1948) –
Chartered in 1919 by veterans returning from World War I,
Alonzo Cudworth American Legion Post #23 was for many years
one of the largest in Wisconsin, with a membership of more
than 5,000 in the 1950s. The Cudworth Post was located
at 1756 North Prospect Avenue. The building was razed in 2002,
and the Legion Post now leases space in the Whitefish Bay
Woman's Club building.

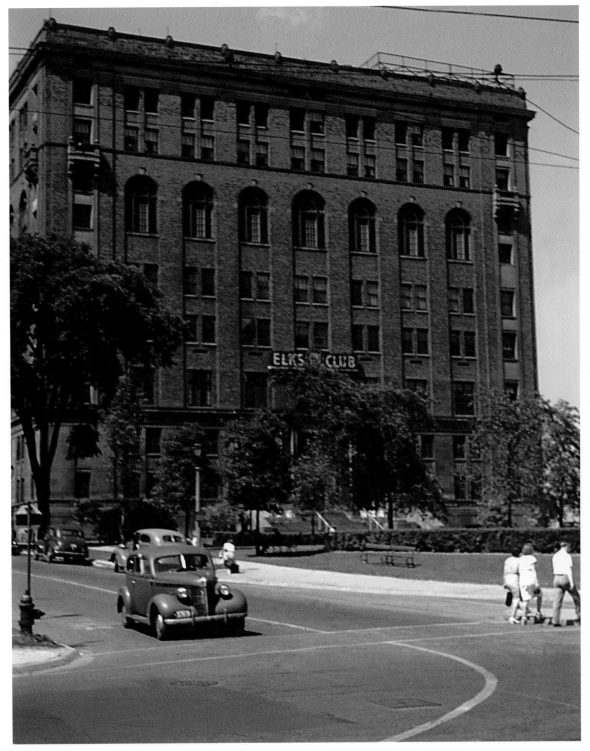

Elks Club (1946) –
Located at 910 East Wisconsin Avenue, the Elks Club was constructed in 1924. Throughout its history, the lodge played host to many different types of social events, from political rallies to wedding receptions. The nine-story building was demolished in 1971, and today a Northwestern Mutual office building occupies the site.

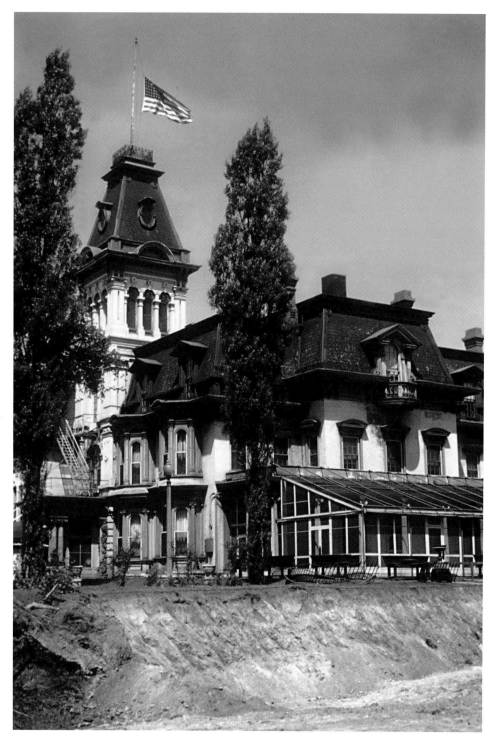

**Deutscher Club /
Wisconsin Club (1949) –**
The residence of financier Alexander
Mitchell was expanded by architect
Edward Townsend Mix in 1870 to
include a tower and mansard roof.
The property, which occupied a full city
block at Ninth and Spring Street
(now West Wisconsin Avenue), was
purchased by the Deutscher Club in
1895. Although its name was changed
to the Wisconsin Club in response to
anti-German sentiment during
World War I, the private club continues
to occupy the building to this day.

MILWAUKEE

PARKS AND RECREATION

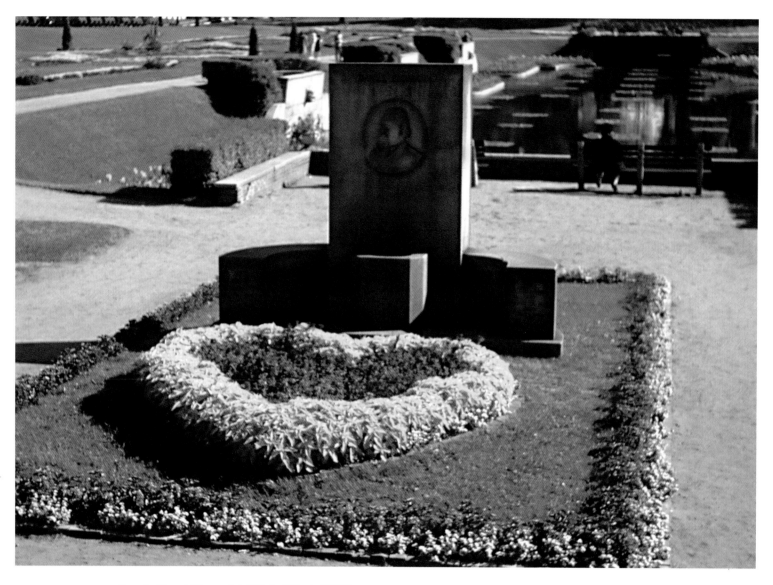

Purple Heart Memorial, Mitchell Park (1946) –
Originally developed by Alexander Mitchell as a private park called
Mitchell's Grove on the bluff overlooking the Menomonee Valley,
Mitchell Park was one of the first properties purchased by the City
of Milwaukee Park Board following its formation in 1889. The park
has historically been the site of a conservatory, the first of which was
built in 1898. Following transfer to the County Park System in 1907,
the Mitchell Park conservatory was substantially reconstructed in
1922 and 1932, and the "Domes" were built as part of a major
expansion in the 1960s. The Purple Heart Memorial and sunken
garden typify post-war floral displays.

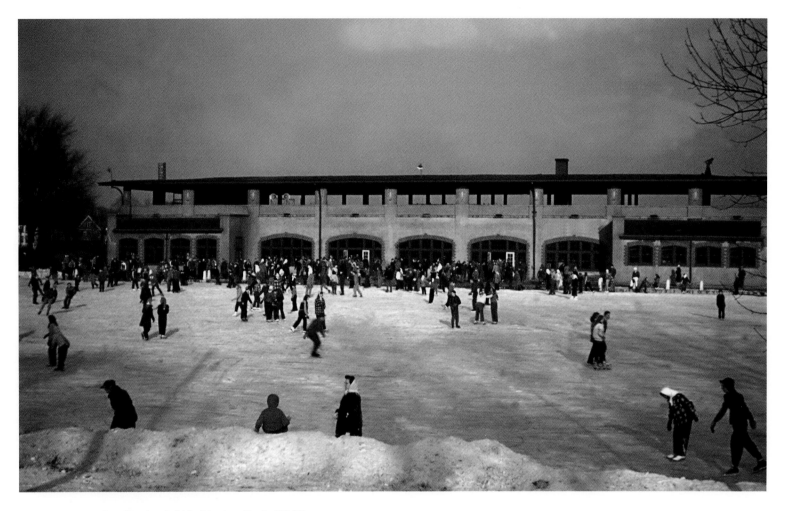

Ice Skating in Washington Park (1949) –
Designed by Frederick Law Olmsted, the creator of Central Park
in New York City and Lake Park in Milwaukee, Washington Park
was once home to the Milwaukee County Zoo and a lagoon
where visitors could rent rowboats during the summer or ice skate
during the winter. The boathouse alongside the Washington Park
lagoon originated as a grandstand for an athletic field and horse
racing track. Later, it served as a concession stand and open-air
dance pavilion during the summer months and as a warming house
for skaters during the winter. The boathouse was demolished in
1977 and replaced by the Washington Park Community Recreation
Building the following year.

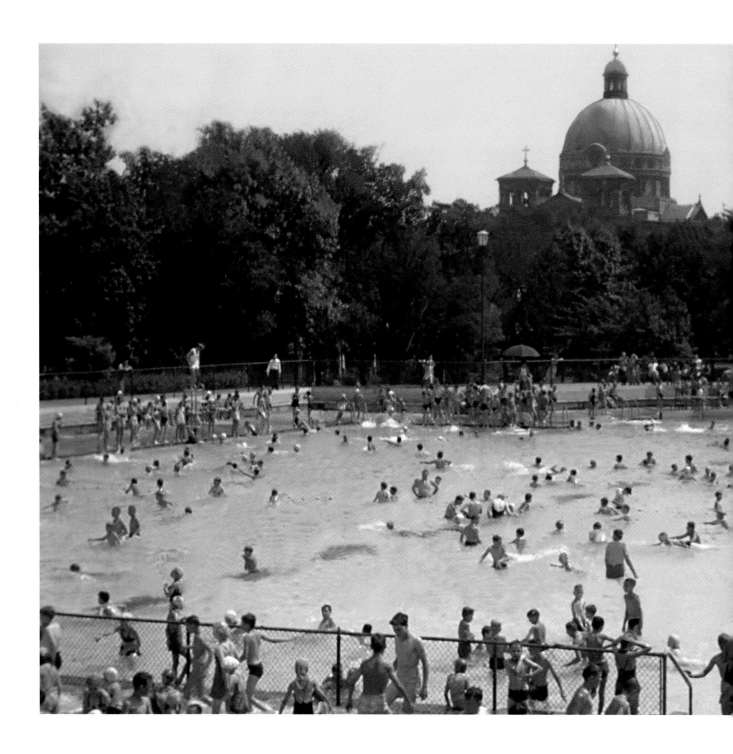

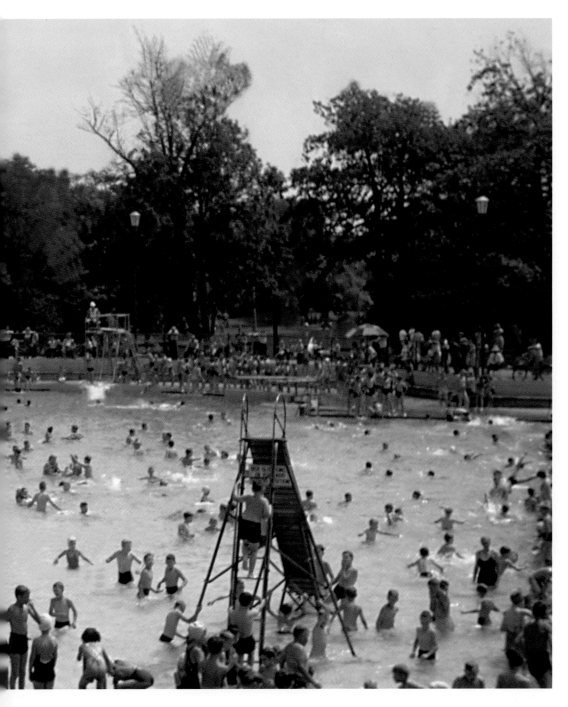

Kosciuszko Park Pool (1946) –
Like Mitchell Park, Kosciuszko Park on Lincoln Avenue was another of the five original parks for which the City of Milwaukee Park Board purchased land in 1890. The Kosciuszko Park Pool was one of many improvements made to Milwaukee County Parks during the Depression with the assistance of the federal Works Progress Administration. Plans for the pool were approved in 1939 and construction was begun in 1941. The pool served the neighborhood surrounding the Basilica of St. Josaphat for over fifty years until Pelican Cove Water Park replaced the deep well pool in Kosciuszko Park in 1997.

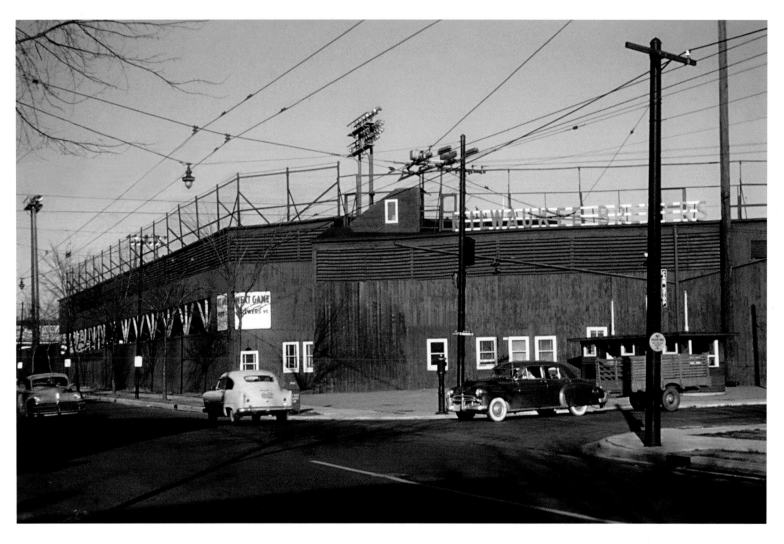

Borchert Field (1952) –
Constructed in 1888 and originally known as Athletic Park, Milwaukee's
favorite early ball field was located at Eighth and Chambers Streets on the near
North Side. The stadium, which occupied one city block and was rectangular in
outline, was the home of the minor league Milwaukee Brewers from 1902 to
1952. The ballpark was officially renamed Borchert Field in 1927 following the
death of Otto Borchert. The flamboyant owner and president of the Brewers
baseball club from 1920 to 1927, Borchert was also the owner of the stadium.
Photographed during its last year of operation, Borchert Field was subsequently
demolished to accommodate freeway construction. It was replaced the
following year by Milwaukee County Stadium, and the minor league Brewers
gave way to the major league Milwaukee Braves.

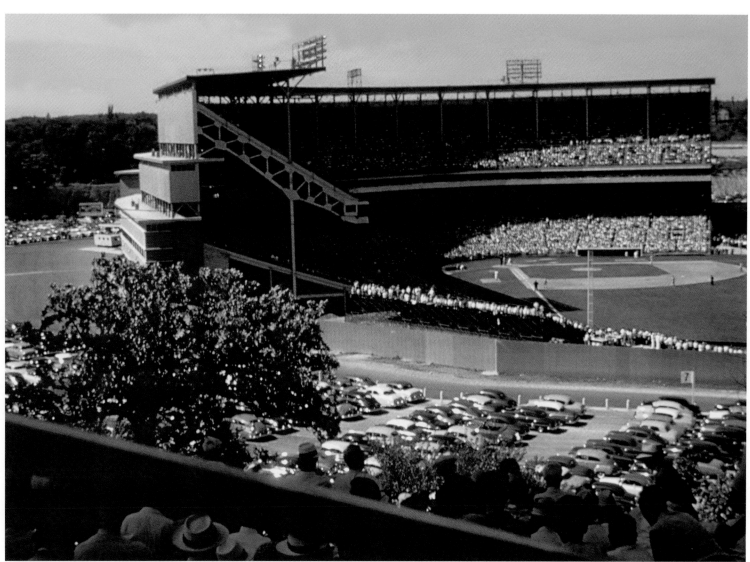

Milwaukee County Stadium (1952–1953) –
The construction of a sports stadium to serve the Milwaukee community
was one of the major elements of Milwaukee County's post-World War II public
works program. (See inset.) The County Park Commission was given responsibility
for the project and broke ground at the Story Quarry site in 1950. Just prior to
the stadium's completion in 1953, Lou Perini won National League approval to
move his Boston Braves to Milwaukee where they set a league attendance record
during their first year. Following the Braves departure to Atlanta in 1965, County
Stadium became the home of the Milwaukee Brewers in 1970. The team
continued to use the facility until the new Miller Park opened in 2001.

Centurama Stage: Overview (1946) –
Milwaukee marked its one hundredth birthday in 1946 with a month-long lakefront celebration called the Centurama. From July 12 through August 11, the shoreline hosted a wide variety of activities: plays, concerts, water ballet, a carnival midway, air shows, military exhibits and thirty-one consecutive nights of fireworks. In all, nearly three million people attended the centennial celebration. The Centurama main stage and surrounding bleachers were located on the lakefront near the foot of Wisconsin Avenue.

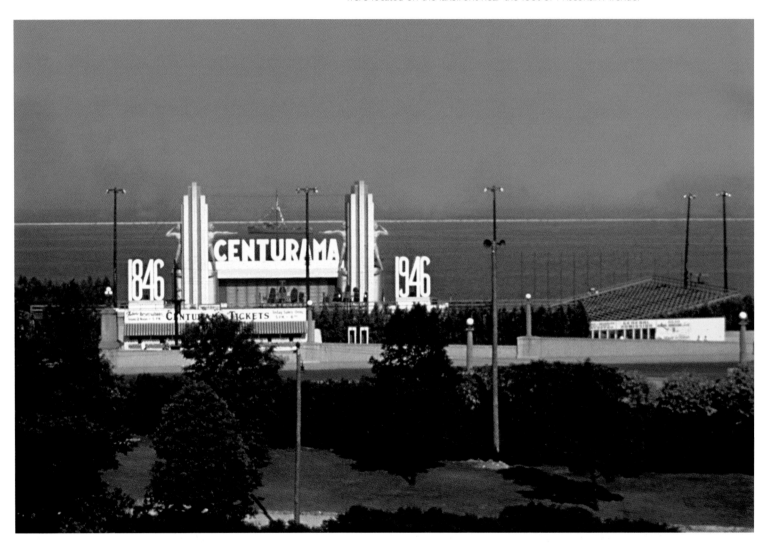

Centurama Parade: Automobile with Dennis Morgan and Jack Carson (1946) – The Hollywood movie "Two Guys from Milwaukee," opened July 25, 1946, in conjunction with the Centurama celebration. The film's stars, Dennis Morgan and Jack Carson, ride in the Centurama parade where they are mobbed by 100,000 adoring fans.

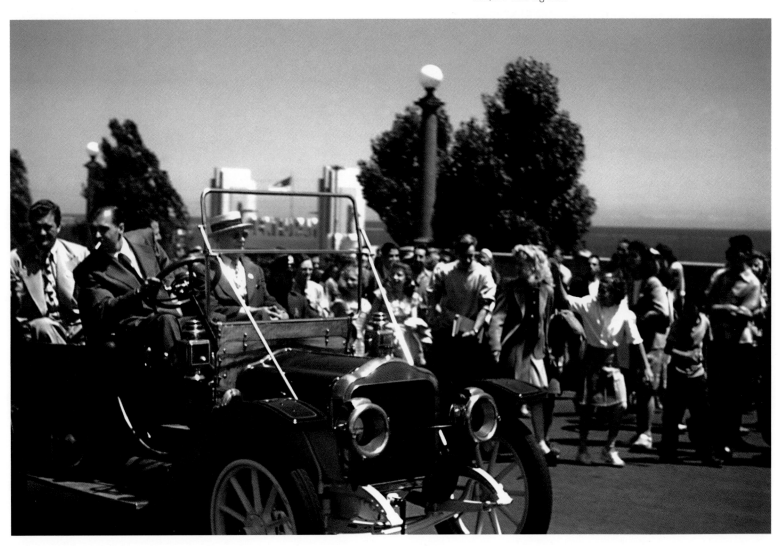

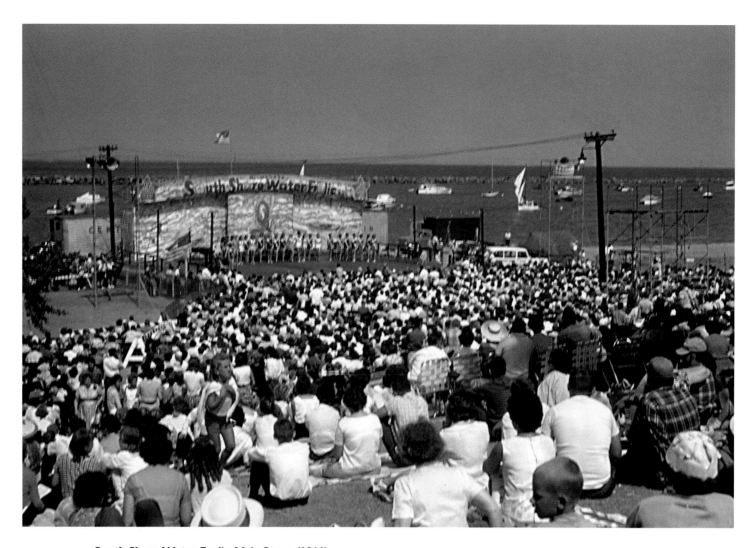

South Shore Water Frolic: Main Stage (1961) –
Established in 1948 as an annual celebration by the Inter-Organization
Council of Bay View, the South Shore Water Frolic continues to be a
popular mid-summer attraction to this day. The festival originally featured
a parade through the Kinnickinnic Avenue business district, stage
shows at the lakefront, a beauty pageant and the "atomic fireworks."
The Water Frolic also included water-related activities such as motor
boat races, water ski shows and, in the early years, a Venetian boat
parade. Here a crowd of people gathers on the hillside overlooking the
main stage in South Shore Park to view the swimsuit competition
at the Thirteenth Annual South Shore Water Frolic.

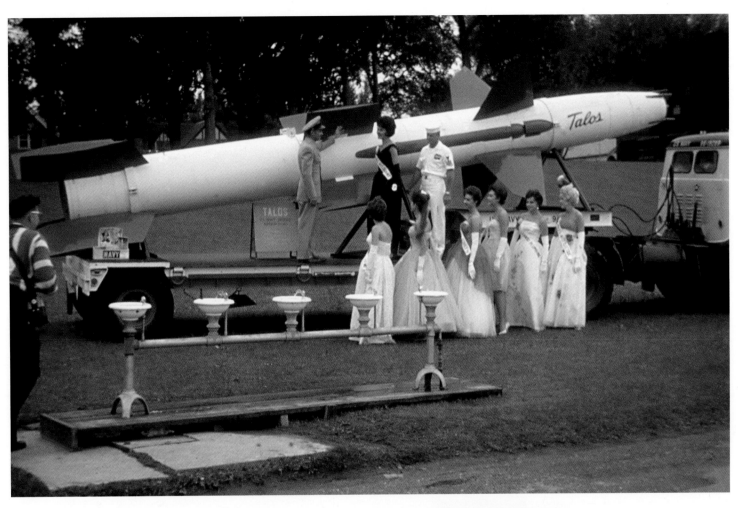

**South Shore Water Frolic:
Missile Display and Beauty Queens (1962) –**
Representatives of the United States Navy
display a Talos missile to contestants in the South
Shore Water Frolic beauty contest. The presence
of the distinctive row of "bubblers" in the
foreground suggests the location of the scene
in South Shore Park.

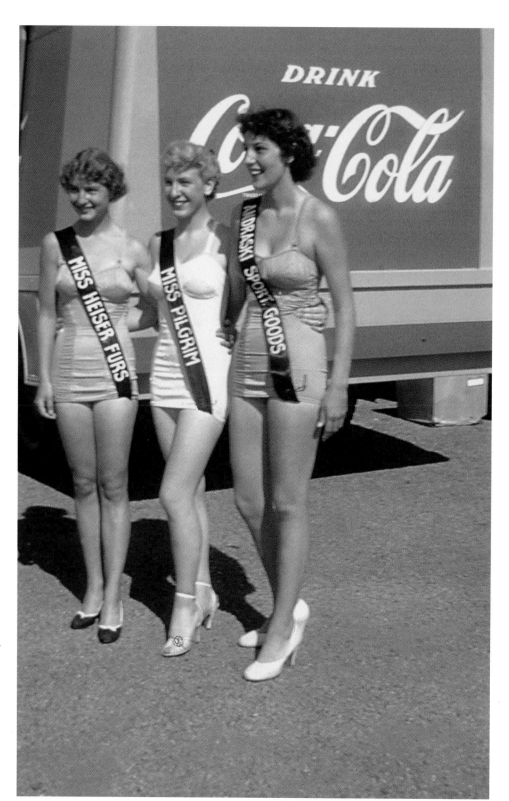

**South Shore Water Frolic:
Swimsuit Competition (1952) –**
Contestants representing various local
businesses pose during the swimsuit
competition leading to the selection of the
Queen of the 1952 South Shore Water Frolic.

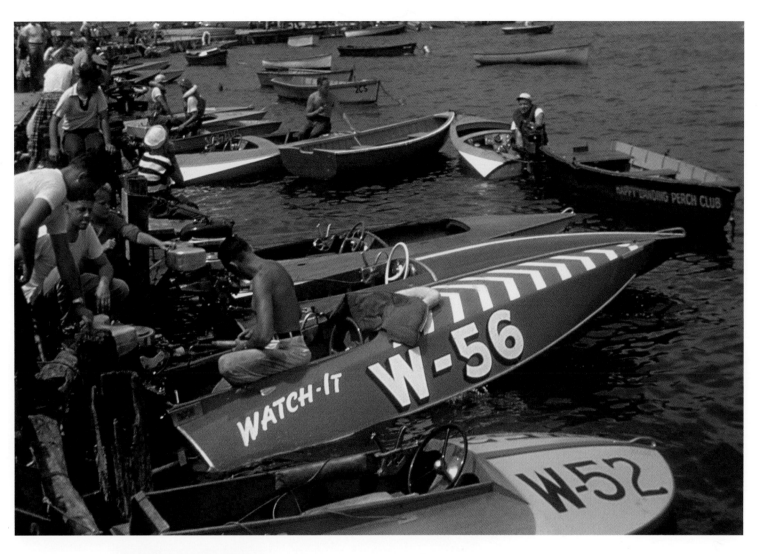

South Shore Water Frolic:
Speedboat Races (1953) –
Local boat racing enthusiasts prepare their
speedboats for the annual competition as part
of the 1953 South Shore Water Frolic

**Wisconsin State Fair:
Blatz Pavilion (1962) –**
The first Wisconsin State Fair was held
in Janesville in 1851. For forty years
thereafter, the Fair migrated to various
Wisconsin cities and towns until finally settling
in West Allis in 1892. All of Milwaukee's
major breweries once took part in the
Wisconsin State Fair. Here the Blatz mascot
proudly proclaims the brewery to be first in
sales in Milwaukee for the thirteenth
straight year.

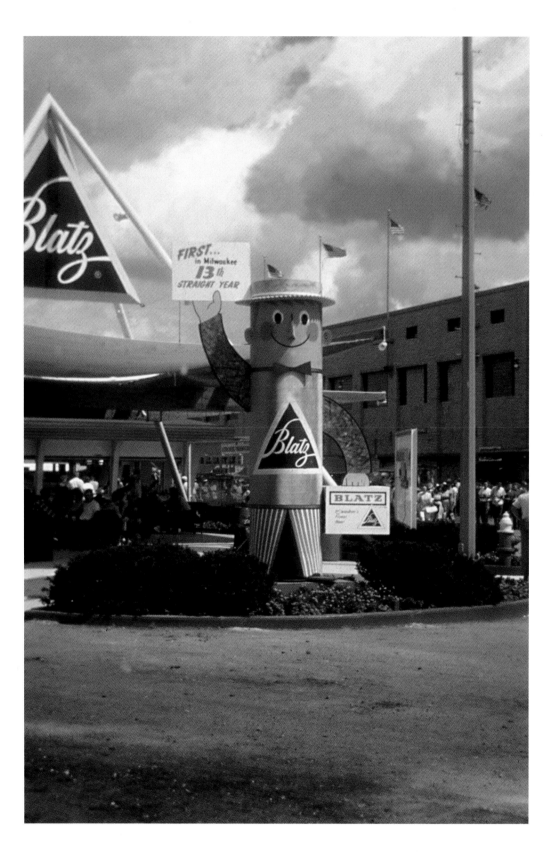

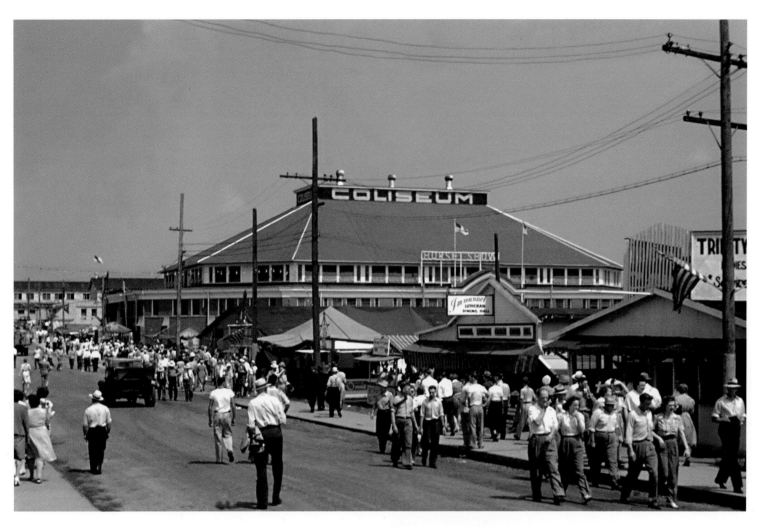

Wisconsin State Fair:
Coliseum Building (1946) –
The State Fair Park Coliseum was constructed in 1905. It was the scene for horse shows, cattle judging and the blue ribbon auction during the State Fair each year. The building was also used for roller derby contests and, in the 1940s, for an early performance of "Holiday on Ice." The building was razed in 1975 and replaced the following year with a new open-air structure.

Wisconsin State Fair:
Oscar Mayer Wienermobile (1992) –
The Oscar Mayer Wienermobile has close ties to
Wisconsin. Not only is its parent company based in
Madison, but the design of the vehicle was also developed
by noted Milwaukee industrial designer Brooks Stevens.
In 1958, Stevens reshaped the company's original 1936
design by "putting the wiener in the bun." He used
molded fiberglass construction on a Jeep frame to create
the classic shape shown in this photograph taken
at the Wisconsin State Fair.

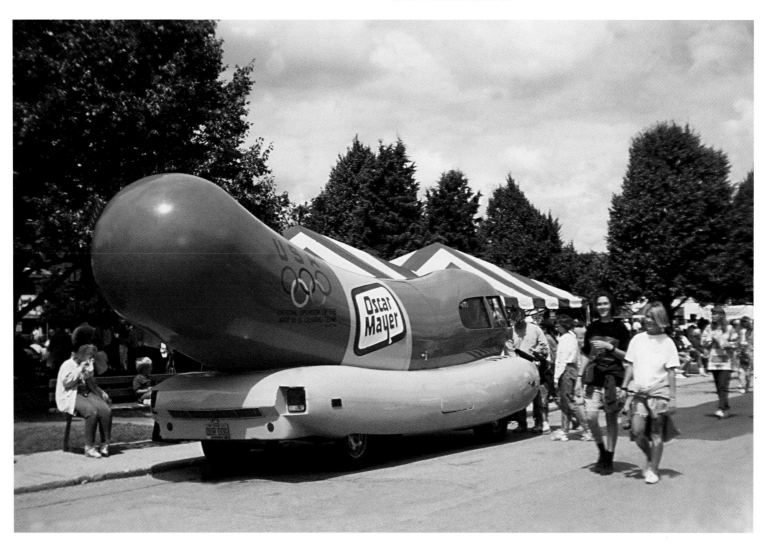

Ralston Rocket (c. 1953) –
During the 1950s, science fiction television programs
enjoyed a great deal of popularity, and sponsors like
Ralston Purina attempted to capitalize on their association
with series like "Space Patrol" starring Commander Buzz
Corry. The company developed the "Ralston Rocket,"
a trailer-mounted space ship which traveled across the
country to fairs and strip malls promoting the company's
cereals. It is shown here during a visit to Milwaukee
just as a young Space Cadet climbs aboard.

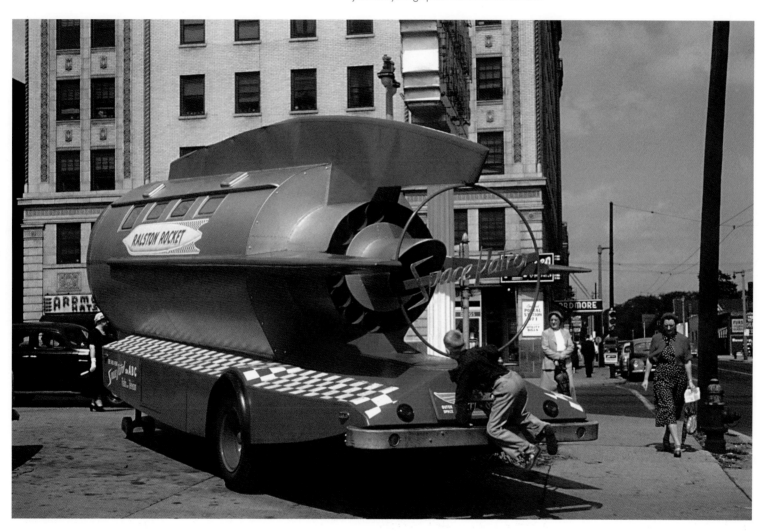

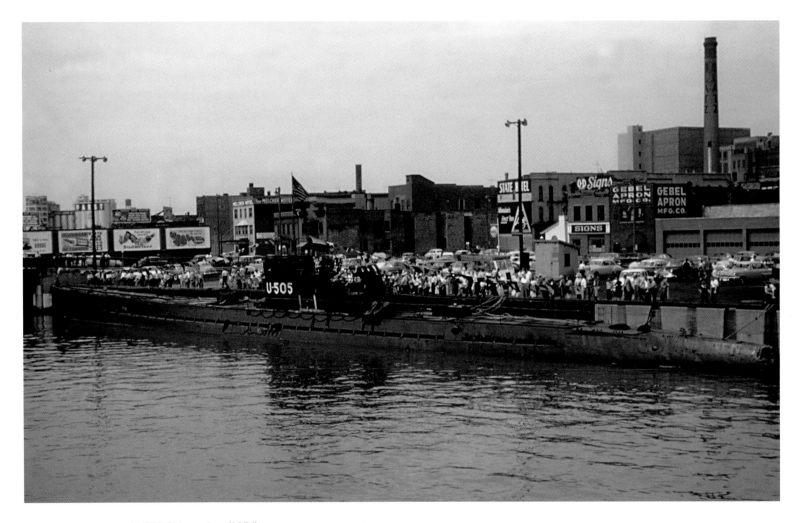

U-505 Submarine (1954) –
On June 4, 1944, the German submarine U-505 was captured off
the coast of West Africa by an American anti-submarine patrol and secretly
towed to Bermuda so that its military secrets might be studied. Thereafter,
the Navy intended to use the sub for target practice. However, it
was rescued in 1953 by Retired Admiral Daniel V. Gallery, a native of
Chicago and the leader of the anti-submarine patrol that captured
the vessel. Working with the Museum of Science and Industry, Gallery
persuaded the Navy to donate the sub for display in his hometown.
Between May 15 and June 26, 1954, the submarine was towed
from Portsmouth, New Hampshire to Chicago. This photograph of the
vessel was taken while it was in transit and docked in Milwaukee.

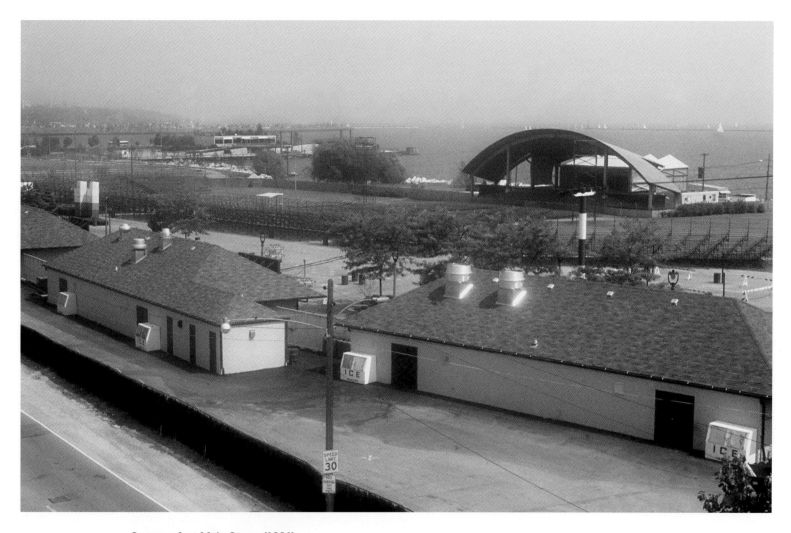

Summerfest Main Stage (1981) –
For the last forty years, Summerfest has brought national musical
acts to Milwaukee's lakefront for a mid-summer festival. Over that
time, the festival grounds have undergone considerable growth and
change, with new stages and amenities added on a regular basis. Here
the Summerfest Main Stage, with its arched roof, faces westward away
from Lake Michigan. The service buildings in the foreground date
back to the period when the grounds were occupied by an
Army Nike Missile Site.

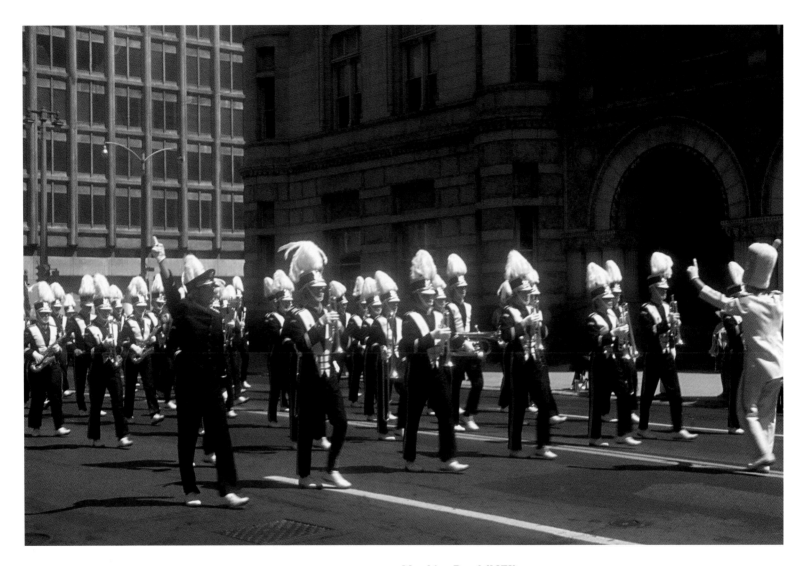

Marching Band (1973) –
The marching band from St. Mary's of Menasha parades
past the Federal Courthouse on East Wisconsin Avenue while
participating in a state American Legion event.

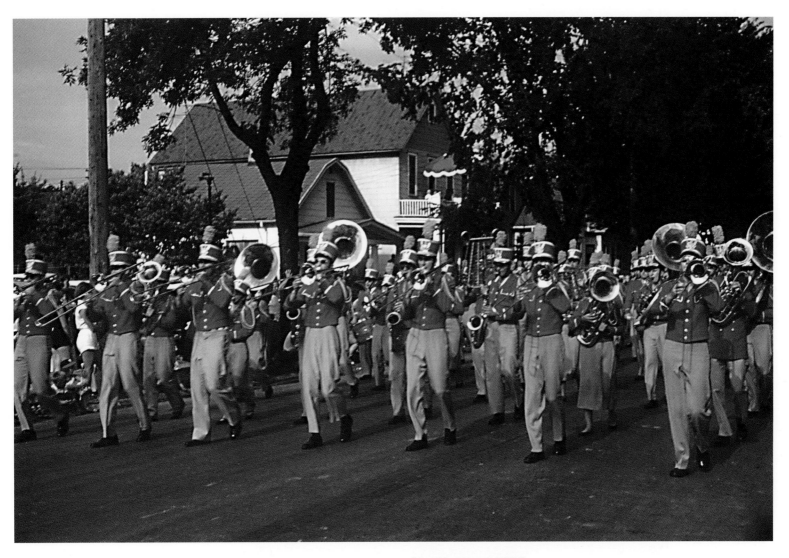

Marching Band (1954) –
A marching band in gold and red uniforms representing
the Catholic Youth Organization of Chicago, Illinois
performs in one of Milwaukee's many parades.

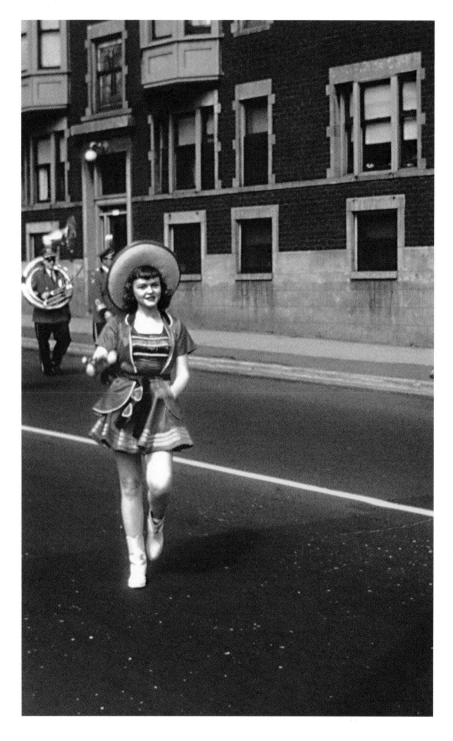

"Girl in the Moon"
Baton Twirler (1954) –
Dressed in a costume reminiscent
of that worn by the Miller Brewing Company's
famous "Girl in the Moon," a baton twirler
parades down a Milwaukee avenue.

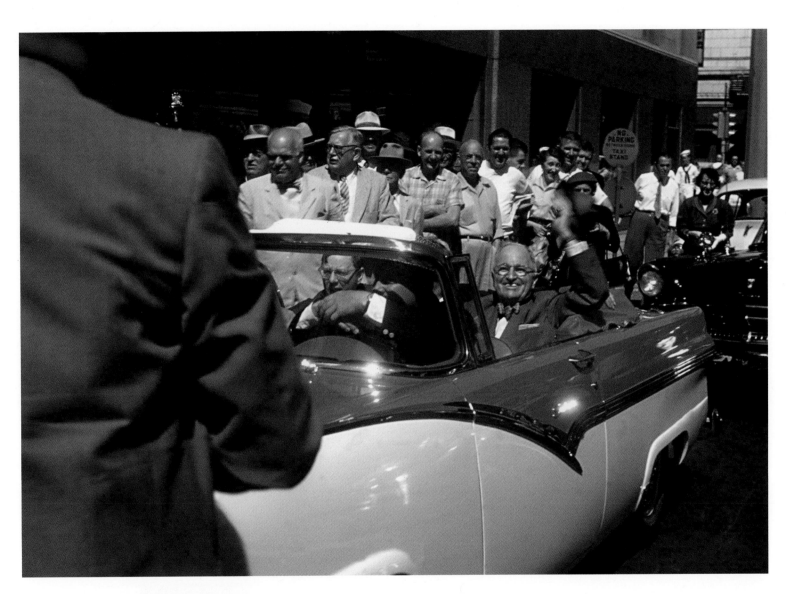

Presidential Motorcade:
Harry S. Truman and Frank Zeidler (1957) –
Former President Harry S. Truman joins Milwaukee Mayor
Frank Zeidler in greeting constituents during a visit to
Milwaukee in 1957. The two men worked together on the
Housing Act of 1949, which sought to combat the
shortage of homes for low income and working class people
following World War II. Little or no security is evident
as the motorcade advances down the street.

**Third Ward Italian Festival Procession:
Banners (1948) –** Men and women
from Milwaukee's Italian community carry the
banners of various organizations and
societies during a festival procession from
Our Lady of Pompeii Church in the Third Ward.

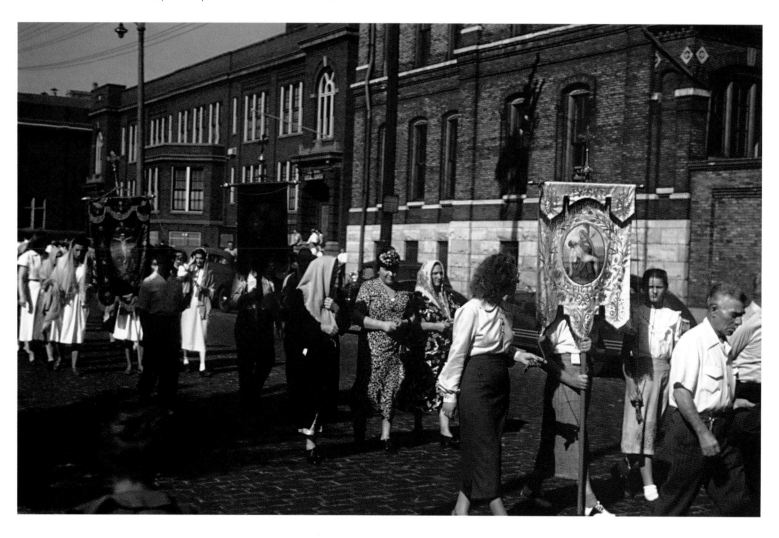

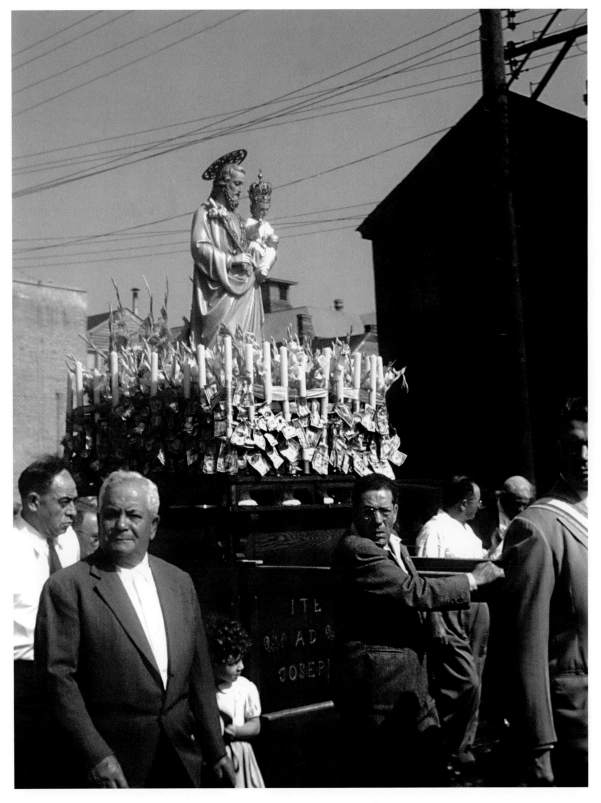

Third Ward Italian Festival Procession: St. Joseph (1950) – Italian community members carry a statue of St. Joseph through the Third Ward during a festival celebration. These Saint's Day festivities would eventually lead to the development of *Festa Italiana*, the annual summer celebration of Italian culture that continues to this day at Henry W. Maier Festival Park on the lakefront.

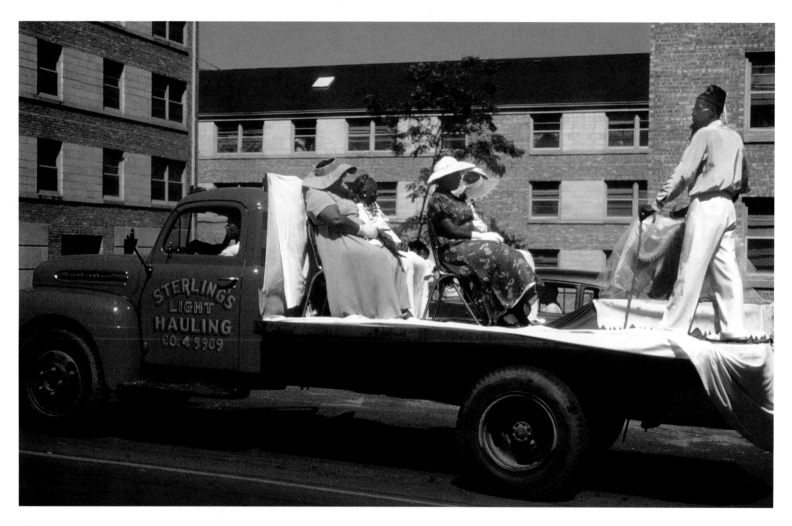

African-American Parade Participants (1952) –
Members of Milwaukee's African-American community gather for
a parade sponsored by the Colored Elks Club, as the fraternal organization
was known at the time. Participants ride on floats mounted on trucks
owned by community businesses, and members of the Women's Auxiliary
gather in a park in conjunction with the event.

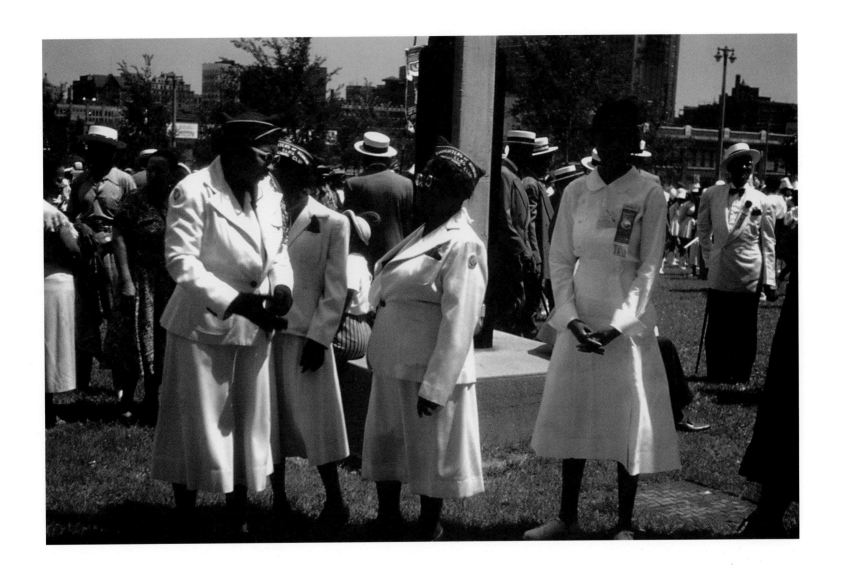

Entertainers: Lionel Hampton (1949) –
During the late 1940s and early 1950s, many nationally recognized
musicians visited Milwaukee and offered live performances. Lyle Oberwise
attended many of these shows and photographed the stars as they performed.
Here he records vibraphonist Lionel Hampton in concert. Hampton's
appearance in Milwaukee was especially notable since he had
attended St. Benedict the Moor School as a youngster.

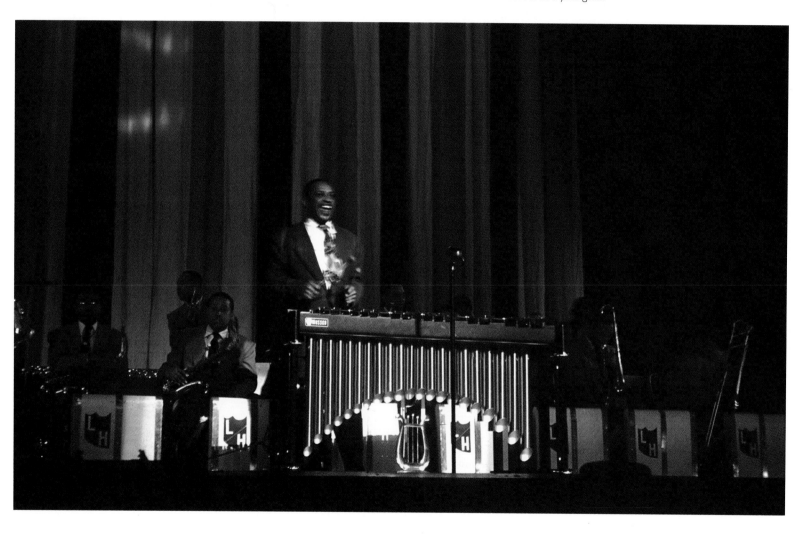

Entertainers: The Four Aces (c. 1953) –
Among the most popular vocal groups of their time,
the Four Aces perform in Milwaukee around 1953.

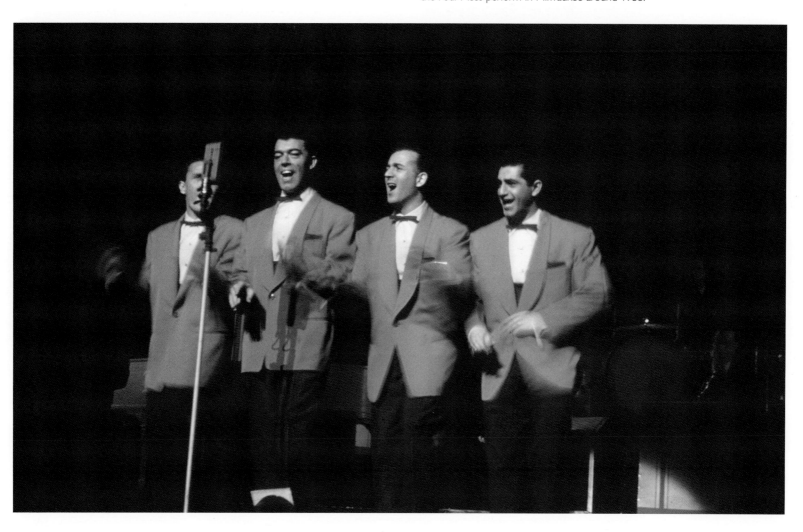

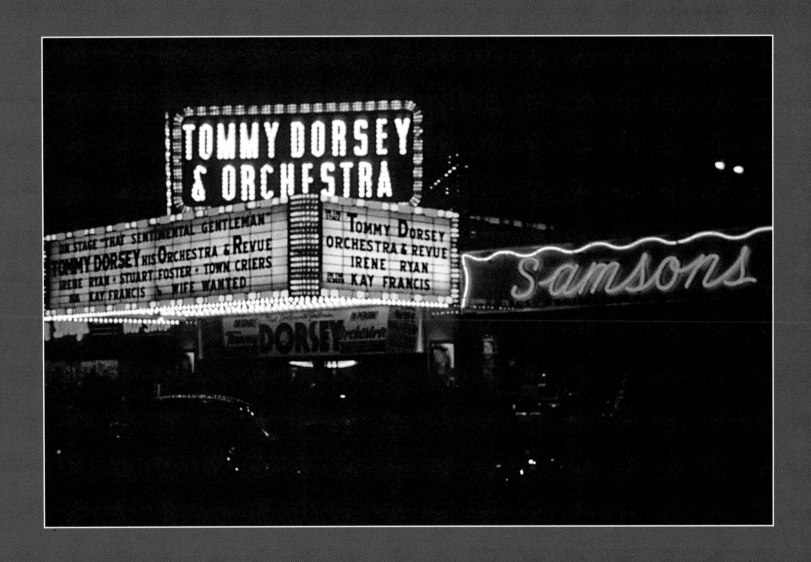

Entertainers: Tommy Dorsey (1947) –
Tommy Dorsey and his Orchestra, one of the most popular touring
groups of the Swing Era, play at the Riverside Theater in 1947. Lyle Oberwise
not only photographed the band's performance, but he also captured
the theater marquee emblazoned with their name.

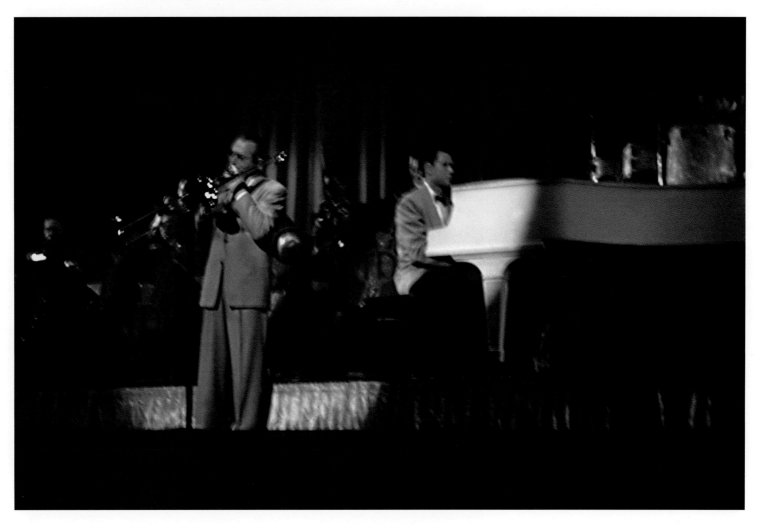

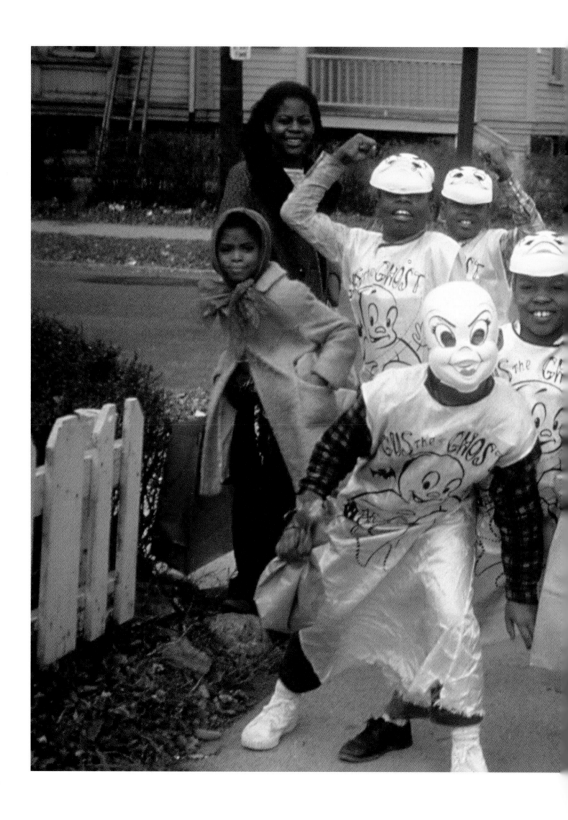

Child's Play: Halloween Trick-or-Treating (1966) –
A group of African-American youngsters Trick-or-Treating in full Halloween costume is the focus of this exceptional photograph. The image captures all of the children's excitement and spontaneity within the context of a beautifully balanced composition, leaving viewers with a true sense of the joyful nature of this holiday tradition.

Child's Play:
Kiddie Train Ride (1948) –
Children's rides were popular attractions
at church picnics, fairs and festivals
throughout the 1940s and 1950s.
Small amusement parks were also
semi-permanent fixtures at shopping
centers such as Capitol Court
during this time period.

MILWAUKEE

COMMERCIAL BUILDINGS

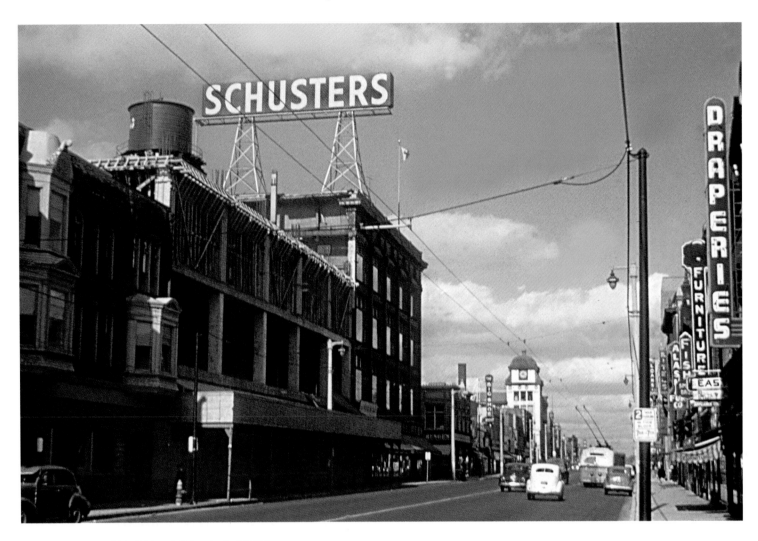

Third Street Schuster's (1949) –
Schuster's Department Store was established in 1884 by Edward Schuster
with the opening of a store at 1907 North Third Street. In 1894,
Schuster's replaced this facility with its headquarters at Third and Garfield
Streets. A second store was also built in 1894 by Charles Schuster
at Twelfth and Walnut, which was relocated to Twelfth and Vliet in 1911.
Finally, a third store was constructed at Sixth Avenue (now South Eleventh
Street) and Mitchell Street in 1914. Each store anchored an
independent shopping district outside downtown Milwaukee.
Here an addition to the south end of the Third Street store is
under construction. Schuster's opened their last store in the Capitol Court
Shopping Center in the late 1950s, but in 1961 Schuster's
Department Stores was sold to Gimbels.

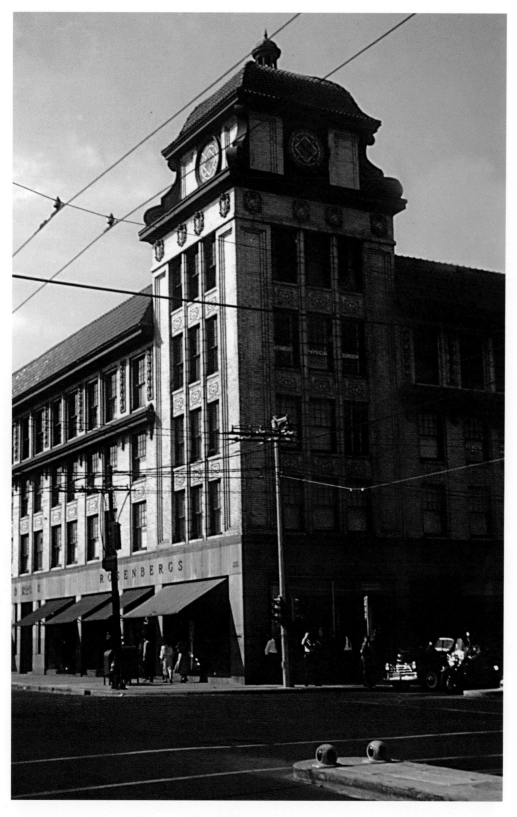

Rosenberg's (1948) –
Located on the northwest corner of
Third Street and North Avenue, Rosenberg's –
like Schuster's – was a fixture of the
Third Street shopping district. Founded in
1900 by A.P. and Benjamin Rosenberg, the
women's clothing store eventually expanded,
opening stores at Capitol Court and
Packard Plaza in 1956 and at Southgate in
about 1958. The Capitol Court and Southgate
stores were sold to Singer's in 1960, and the
store on Third and North closed the same year.

Sears, Roebuck & Company (1949) –
Sears, Roebuck and Company was incorporated in 1896 and, after
years of success in the mail-order business, opened its first retail store in
1925. By 1927, Sears had 27 retail stores in operation, including this
one in Milwaukee, located at the intersection of North Twenty-first Street,
West North Avenue and West Fond du Lac Avenue. Like the three
Schuster's Department Stores, Sears anchored an important North Side
shopping district. In this photograph, a single Milwaukee police officer
directs traffic in the middle of the busy intersection in front of Sears.
Following the opening of additional Sears stores in suburban
shopping centers, the North Avenue Sears store closed in 1980.

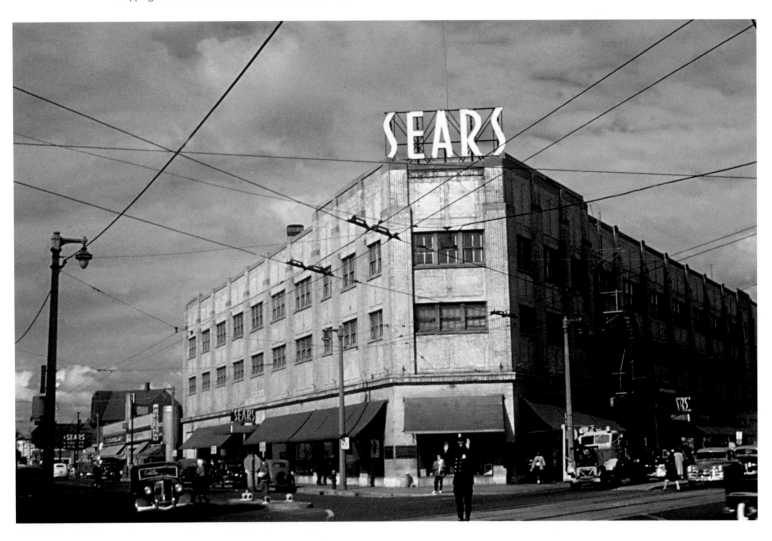

Bayshore Shopping Center (1954) –
When Bayshore Shopping Center on North Port
Washington Road in Glendale opened in 1954,
it was a strip mall – one of the first of its kind in Wisconsin
– anchored by a Sears store. Years later, the mall was
enclosed and Boston Store was added as another
anchor tenant. In 2005, a $360 million make-over
transformed Bayshore Mall once again, this time into an
open-air Town Center.

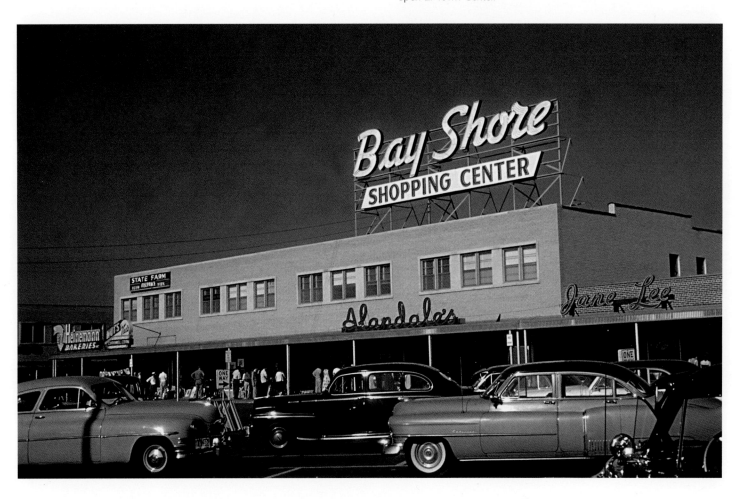

Joseph Schlitz Brewing Company (1946) –
A number of the late nineteenth century structures which made up the Schlitz Brewing Company complex between North Third Street and the Milwaukee River were still in use in 1946.
The buildings shown follow the German New Renaissance style of architecture popular in Europe in the late 1800s.
Once the largest of Milwaukee's breweries and the second largest in the country, Schlitz – "The beer that made Milwaukee famous" – was sold to Stroh's Brewery following a lengthy strike in the 1980s and eventually closed. The brewery buildings were subsequently converted to an office park.

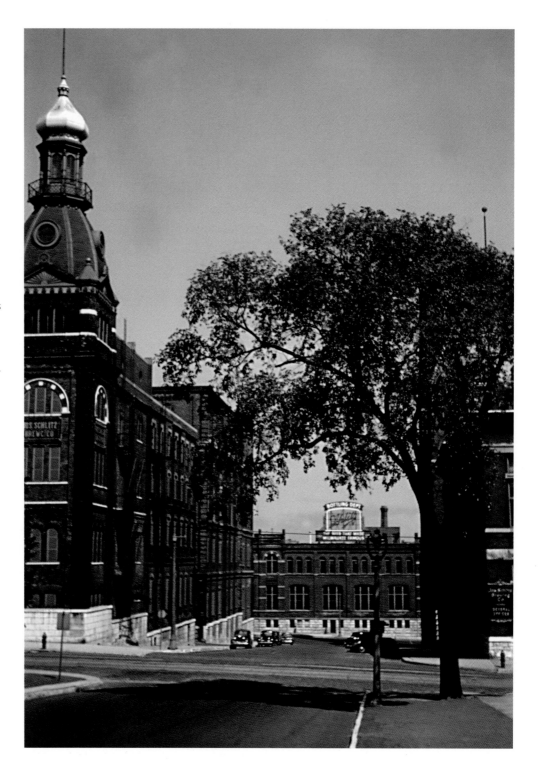

Pabst Brewing Company (1946) –
In 1844 German brewery owner Jacob Best established a new
brewing company in Milwaukee. Best and Company passed into the control
of Jacob's son Phillip in 1859. In 1862 Phillip's daughter Maria married Captain
Frederick Pabst who subsequently became a partner in the corporation.
Following Pabst's ascent to the presidency, the brewery was renamed the
Pabst Brewing Company in 1889. Pabst Brewing was at that time the
largest brewery in the world. In 1985 the company was sold to
Paul Kalmanowitz of California, and eleven years later – after 152 years
in business – the brewery closed. A new redevelopment plan seeks to convert
most of the remaining buildings in the complex located at North Tenth Street
and West Juneau Avenue for residential and commercial use.

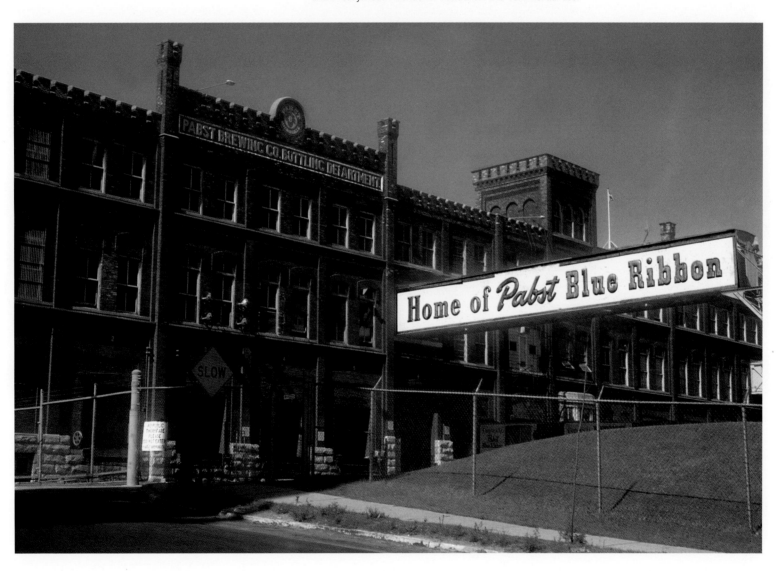

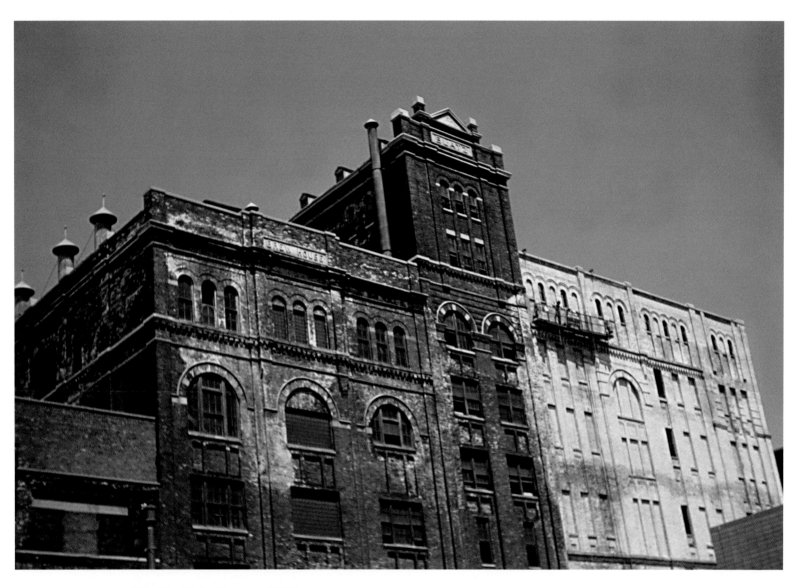

Valentine Blatz Brewery (1986) –
The massive Brew House of the Valentine Blatz Brewery,
located on Broadway and Juneau Avenue, was constructed in 1891.
By that time, Blatz was the third largest brewery in Milwaukee
and the first to sell beer nationally. Eventually, however, Blatz succumbed
to local and national competition and closed in 1959, the first of the
"Milwaukee Four" to go out of business. The brewery's buildings
were subsequently put to alternative uses. Following the cleaning of
its Cream City brick, the Blatz Brew House was converted first
to apartments during the 1980s and then to condominiums in 2006 – 2007.

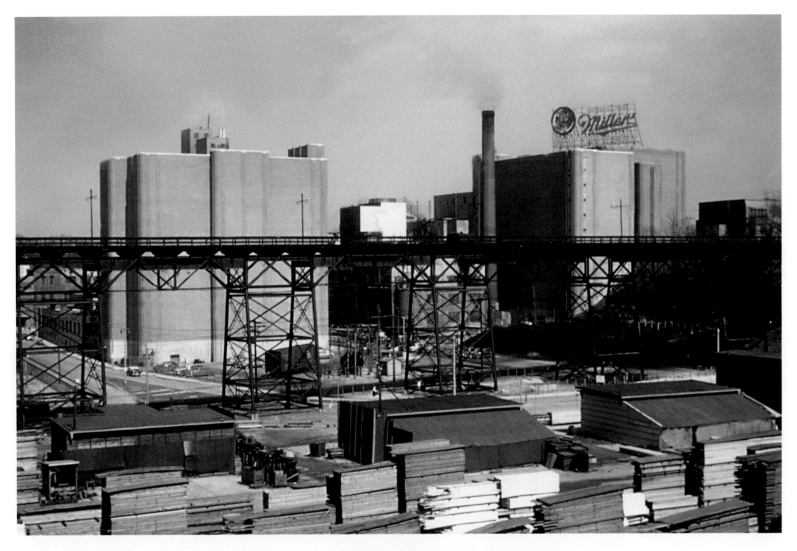

Frederick Miller Brewing Company (1954) –
In 1855, Frederick Miller purchased Milwaukee's "Plank Road Brewery,"
which at that time was located well out in the country, and transformed it
into one of the city's best known businesses. An experienced brewmaster
in his native Germany, Miller expanded his enterprise well beyond the small
number of dilapidated buildings he originally purchased, eventually
laying claim to "Miller Valley" along the banks of the Menomonee River.
In this photograph, the brewery is visible behind the Wells Street
viaduct, which carried the No. 10 streetcar from Wauwatosa to downtown.
The trestle, constructed in 1892, was 2,085 feet long and 90 feet high.
It was demolished in 1962 after the trolley service was discontinued.
Miller remains the second largest brewery in the United States
and retains contracts to produce Pabst and Schlitz beers

Republican House Hotel (1948) –
The Republican House Hotel was designed by architect Fred Velguth. It stood on the northwest corner of Third Street and Kilbourn Avenue, directly across from what is now the Milwaukee County Historical Society. The Republican House was the location of a popular restaurant called George Diamond's Steak House. It was also known as "The Birthplace of the American League" because in 1900 Charles Comiskey signed the incorporation papers for the Chicago White Sox in Room 185, thereby completing the field of eight teams which made up the junior circuit. The Republican House was demolished in 1961.

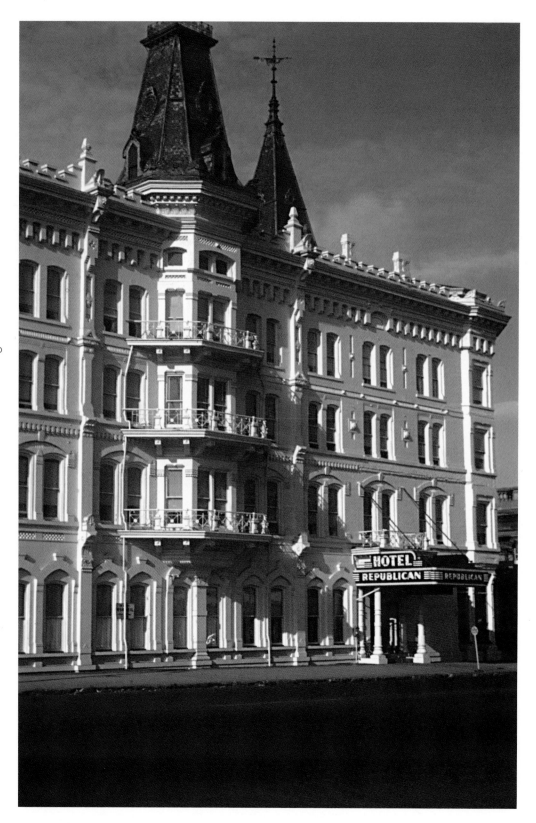

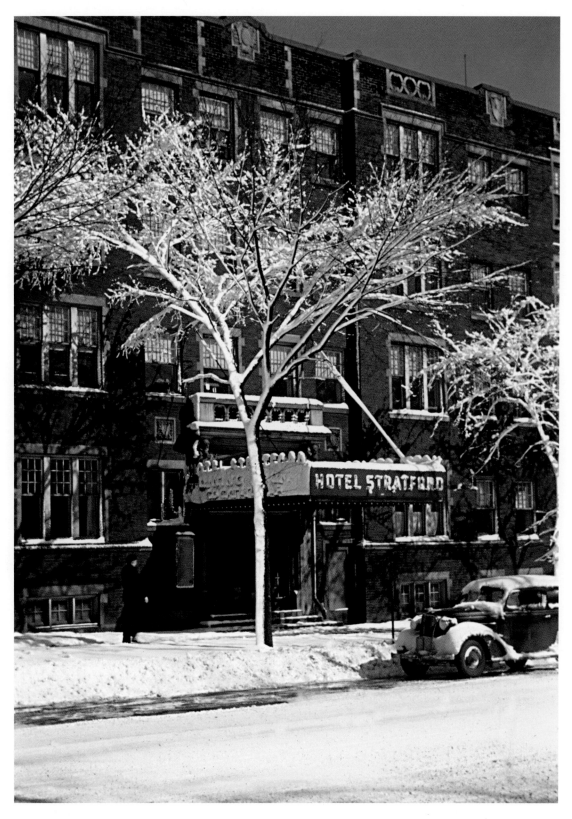

Stratford Arms Hotel (1945) –
The Stratford Arms Hotel, located at 1404
West Wisconsin Avenue, was leased by
Marquette University during World War II
to house military personnel taking college
courses. The property was purchased
by the university in 1962 and, when it opened
as a student residence, the building was
called Heraty Hall after a 1914 graduate of
the School of Medicine. In 1973, the
Marquette administration converted Heraty
Hall from a women's dormitory into
the residence for the university's Jesuit
community. It remains the "Jes-Res"
to this day.

Schroeder Hotel (1946) –
Completed in 1928 according to plans
drawn by the Chicago architectural firm of
Holabird & Roche, the Schroeder Hotel at
North Fifth Street and West Wisconsin
Avenue was among the largest in Wisconsin.
The dream of Milwaukee hotel and insurance
magnate Walter Schroeder, the facility
originally had 811 guest rooms. Towne Realty
purchased the hotel in 1964 and resold
it six months later to the Sheraton chain,
which renamed it the Sheraton Schroeder.
From 1972 through 1995, the Marcus
Corporation owned and operated the property
under the name Marc Plaza. In 1995 the
hotel was sold once again and became
a Hilton franchise, first known as the
Milwaukee Hilton and more recently as the
Hilton Milwaukee City Center.

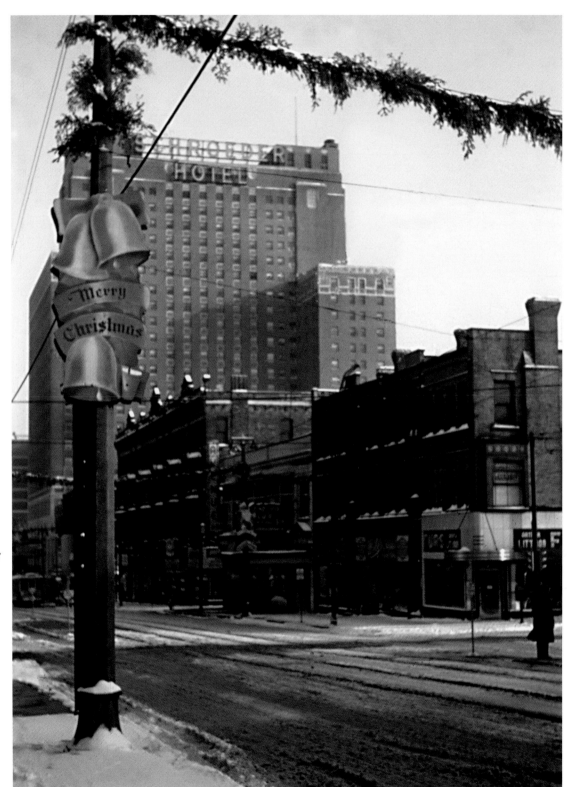

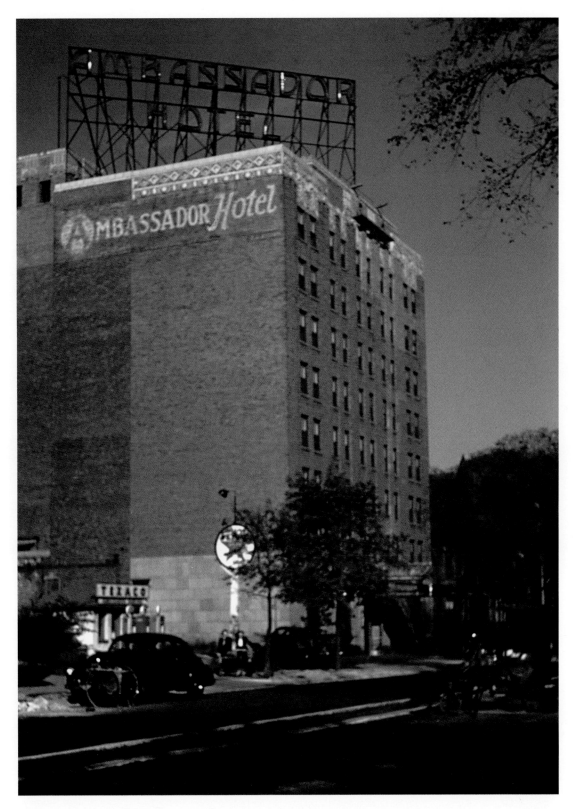

Ambassador Hotel (1947) –
Designed in 1927 by architects
Urban Peacock and Armin Frank, known
for their art deco theaters, the Ambassador
Hotel was a spectacular example of
this architectural style. Once a popular
place for wedding receptions, conventions
and special events, the hotel fell
into decline during the 1980s and 1990s.
A recent restoration has returned the
property at North Twenty-third Street and
West Wisconsin Avenue to its art deco
elegance and replaced the Texaco station in
this image with a private parking area.

Pfister Hotel (1982-1983) –
The construction of a luxurious hotel in downtown Milwaukee
was first conceived by pioneer tanner Guido Pfister and ultimately
carried out by his son Charles. Designed by architects
Henry C. Koch and Herman J. Esser, the Richardsonian Romanesque
building was completed in 1893. In 1962, a twenty-three-story
tower was added to the back of the hotel on the site of the original
Pfister home. The elegant Victorian lobby was restored in 1992,
qualifying the Pfister for membership in the Historic Hotels of
America. In the early 1980s when this photograph of the Pfister was
taken, the Goldsmith Building and Chapman's Department Store
immediately across Wisconsin Avenue had just been demolished to
permit construction of the 411 East Wisconsin Center.

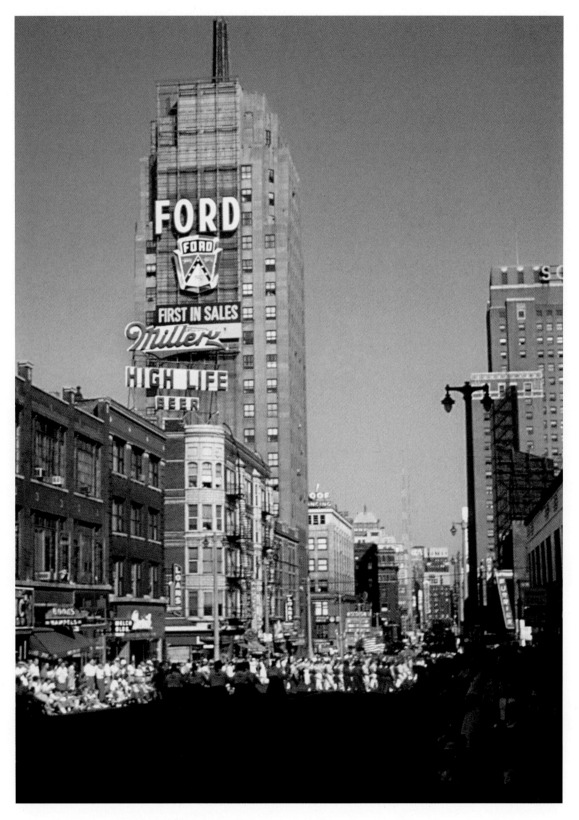

The Milwaukee Tower (1955) –
Designed by Chicago architects
Weary & Alford and completed in 1930,
this high-rise building on the corner
of North Sixth Street and West Wisconsin
Avenue represented a significant addition to
downtown Milwaukee's skyline. Later
called the Wisconsin Tower and the Mariner
Tower after its builder John Mariner,
the structure typifies the "moderne" style
and is adorned with art deco ornament on
the lower levels. The west side of the
tower was for many years the location of
large-scale lighted advertisements for
Ford Motor Company, Calvert Distillery, and
other companies. The building is currently
being converted into condominiums.

**Milwaukee Gas Light Company and
Northwestern Mutual Life Insurance Company (1959) –**
Designed by Milwaukee architects Eschweiler & Eschweiler
and noted for its art deco styling and the weather-predicting flame
at its top, the 1930 Gas Company building provides a perfect
complement to the neoclassical style that inspired Northwestern
Mutual's home office, designed by Marshall & Fox of Chicago and
completed in 1912. Following the merger of Wisconsin Gas
with We Energies, the Gas Light Building was purchased by private
investors in 2002 and restored to its period grandeur. Northwestern
Mutual celebrated its sesquicentennial in 2007.

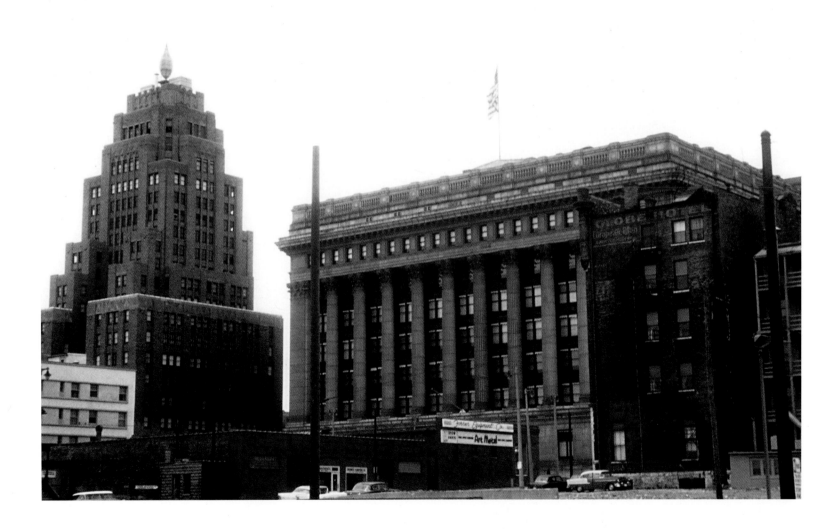

**First Wisconsin National Bank,
Second Ward Office (1947) –**
The third home of the Second Ward Savings Bank to occupy
the triangular site defined by Kilbourn Avenue, Third Street,
and West Water Street (now North Plankinton Avenue), this
handsome Beaux Arts building was designed by Milwaukee architects
Kirchhoff & Rose and completed in 1913. The bank was purchased
by the First Wisconsin National Bank in 1928 and served as the
larger financial institution's Second Ward Office until 1965. At that
time, First Wisconsin donated the building to Milwaukee County
for the use of the Milwaukee County Historical Society. The tower
of the Republican House Hotel is visible in the background.

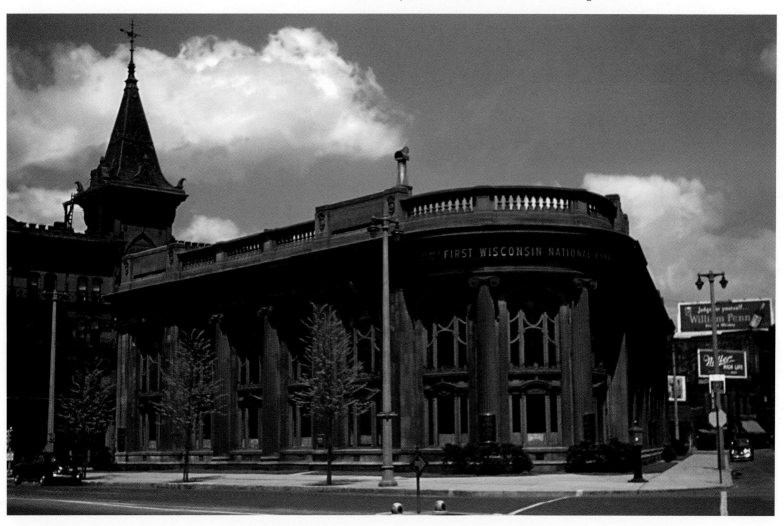

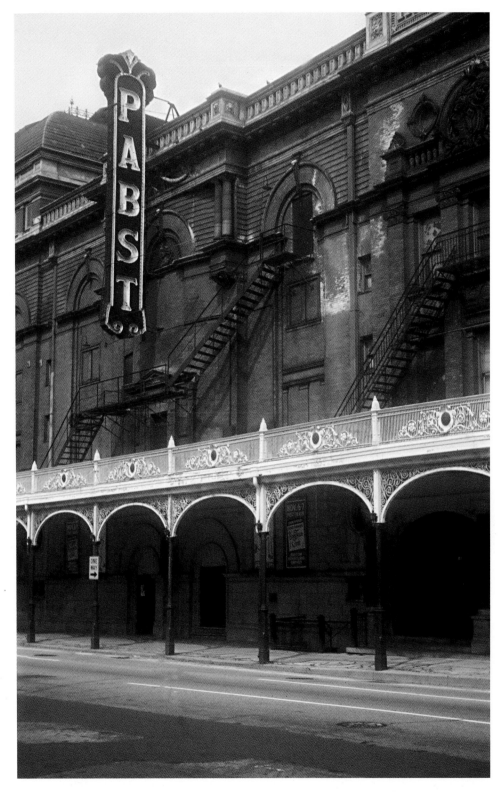

Pabst Theater (c. 1973) –
Captain Frederick Pabst commissioned construction of the Pabst Theater in 1893 following a disastrous fire which consumed most of its predecessor, the Stadt Theater. Prior to extensive remodeling in 1890, the Stadt Theater had been known as Nunnemacher's Grand Opera House. The Pabst Theater, an elaborate Renaissance Revival structure richly decorated with wrought iron, terra cotta and ornamental plaster work, was completed in less than two years. Following a recent restoration, the Pabst remains one of Milwaukee's most elegant performing arts venues.

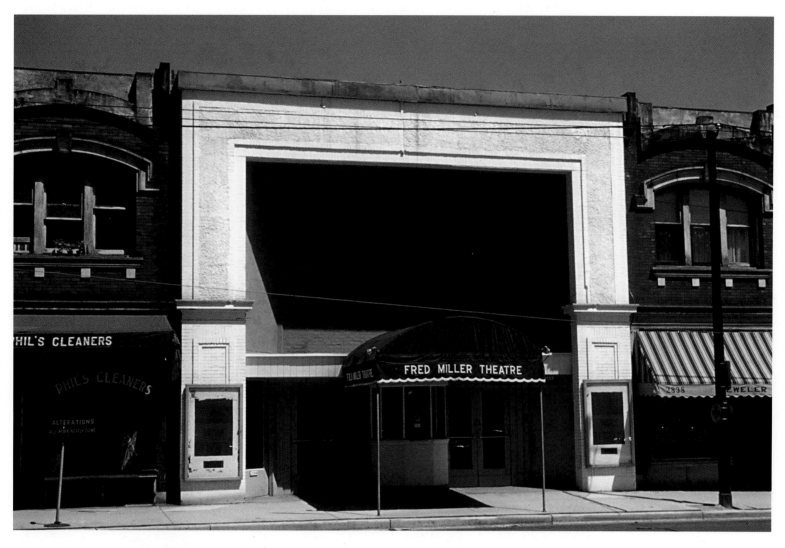

Fred Miller Theater (1954) –
The Fred Miller Theater, forerunner to today's Milwaukee
Repertory Theater, was founded in 1954 in this facility located on
North Oakland Avenue. In 1963, the company adopted the name
Milwaukee Repertory Theater to reflect its commitment to
establishing a resident acting company capable of performing
a broad selection of classical and contemporary works.
The group continued performing in the Fred Miller Theater until
moving to the Todd Wehr Theater at the Performing Arts Center
in downtown Milwaukee in 1968 and subsequently to the
Milwaukee Center. The former Fred Miller Theater continues to
operate as the Miramar Theatre.

Oriental Theatre (1946) –
The Oriental Theatre, located on
North Farwell Avenue just south of East
North Avenue, was designed by
architects Gustav A. Dick and Alex H. Bauer
and constructed in 1927 with seating
for more than 2,100 people. The Oriental
is a classic example of the opulent movie
palaces of the period, featuring a lobby
decorated with six gilded larger-than-life
Buddhas, eight porcelain lions glazed
in black and gold, and nearly one hundred
elephants. Although the balcony has
been closed and the main floor divided
into two smaller theaters, the Oriental
continues to operate to this day.

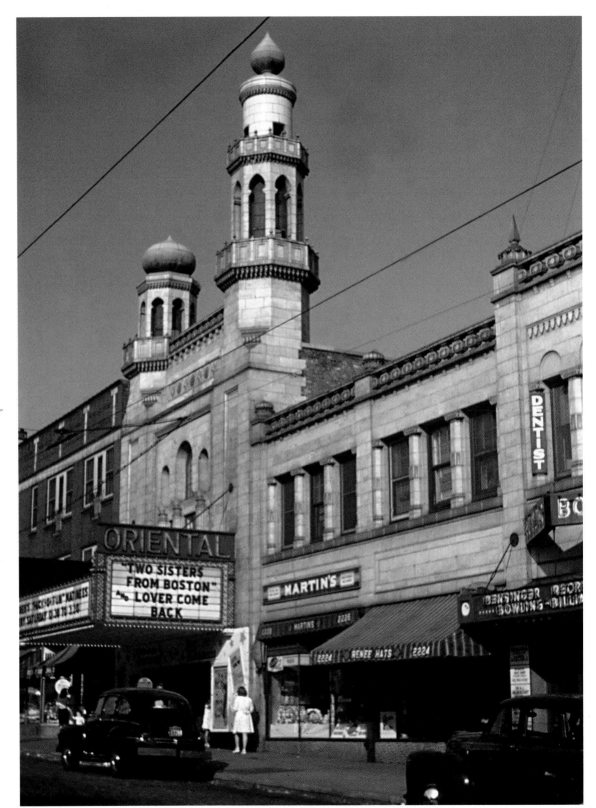

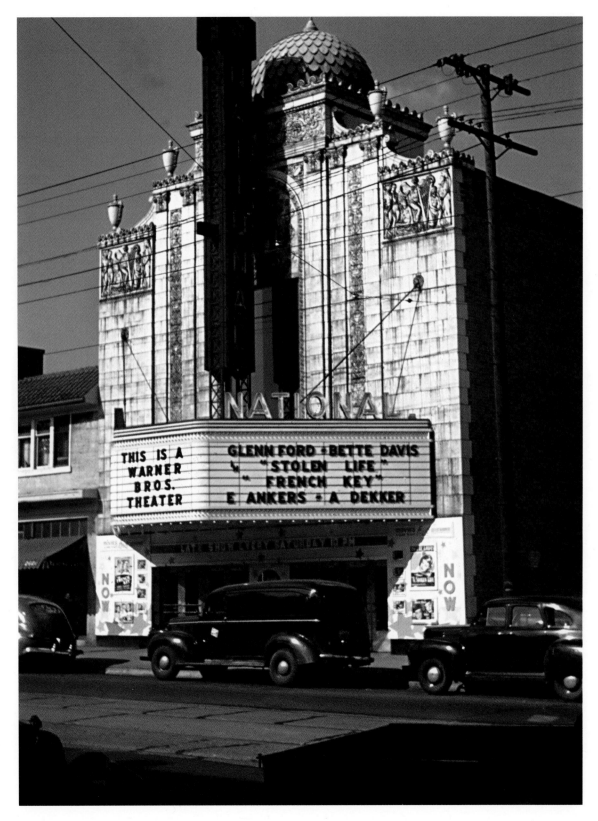

National Theater (1946) –
Located at 2616 West National Avenue, the National Theater served its South Side community from 1928 until 1970.
Also designed by Dick and Bauer, the National seated 1,388 people. In this photograph, the marquee announces a double feature including "Stolen Life" featuring Glenn Ford and Bette Davis, as well as "French Key."

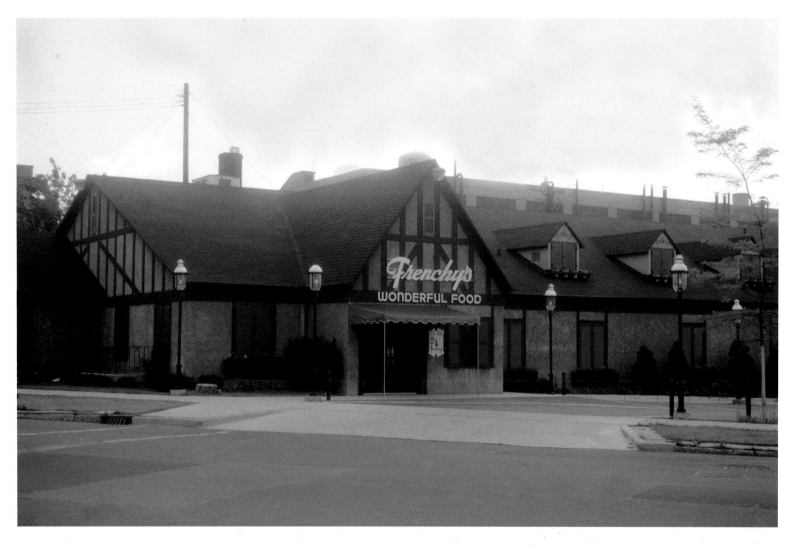

Frenchy's Restaurant (1967) –
Frenchy's Restaurant opened in the mid-1940s in a building at
1827 East North Avenue that dated back to the 1890s.
Because the aging structure required extensive repair, in 1965
Paul "Frenchy" LaPointe purchased a parcel of land just
east of his restaurant where the old North Avenue green
market once operated. Here, in a new one-story
French farmhouse-style building, he re-opened the restaurant
in September, 1966. Frenchy's remained the epitome of
fine dining in Milwaukee until the restaurant closed in 1977.
Today the triangular site is occupied by Beans and Barley,
a vegetarian restaurant.

Mammy's Restaurant (1954) –
Located at North Atkinson Avenue and West Capitol
Drive, Mammy's was one of two restaurants owned in
part by Green Bay Packer legend Charles "Buckets"
Goldenberg. The other was Pappy's, which was a fixture
in the Bayshore Shopping Center for many years.
Mammy's was known for its Southern-style cooking and
proclaimed itself "nationally famous for barbecued ribs."
The restaurant enjoyed great popularity during the
1940s and 1950s.

Holiday House Restaurant (1967) –
Opened in 1949 on the corner of
East Clybourn and North Van Buren Streets,
the Holiday House Restaurant was owned by
John C. Volpe through the 1960s. Described
by its proprietors as the "Toots Shor's of Milwaukee,"
the Holiday House attracted important
figures from the world of sports and entertainment.
An employee fixing her hair outside
the restaurant is the focus of this photograph.

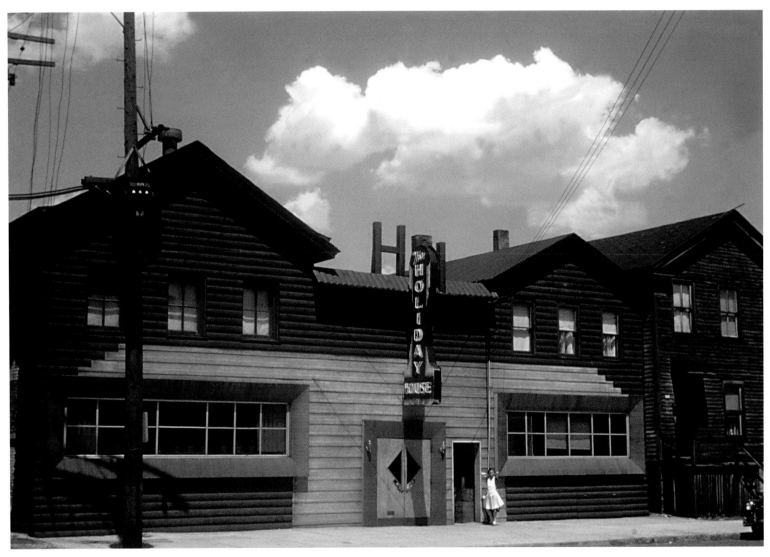

Haymarket Square (1968) –
A relic of years gone by, Haymarket Square
provided feed and bedding for the horses that
pulled Milwaukee's wagons and carriages. Located
at North Fifth and West McKinley Streets,
the Haymarket still boasted a small collection
of horse-drawn wagons years after they
had fallen from common usage.

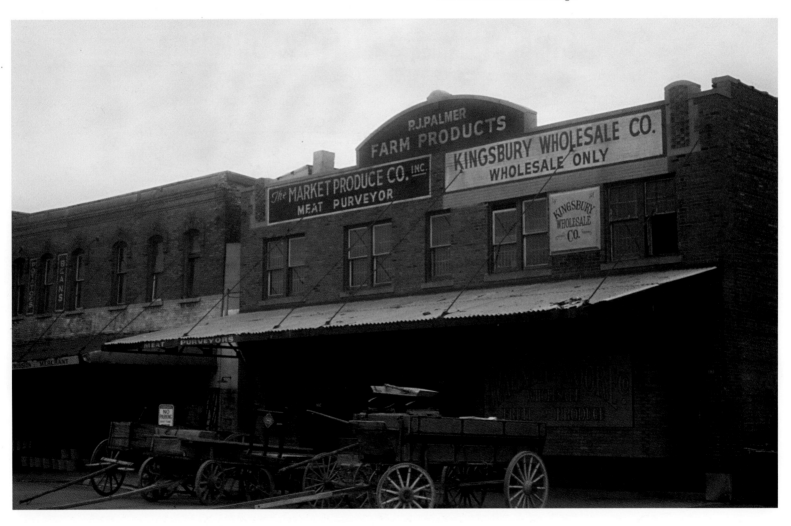

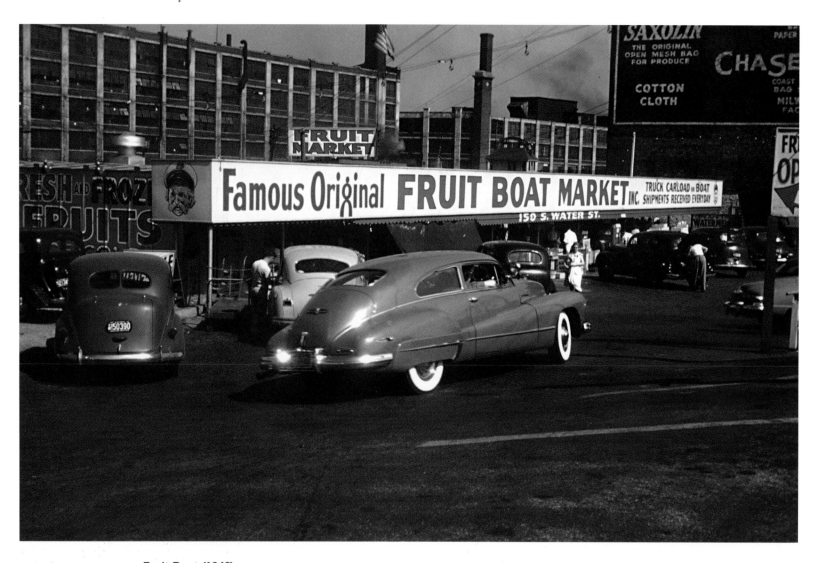

Fruit Boat (1948) –
The original Fruit Boat, located at 150 South
Water Street along the Milwaukee River in Walker's
Point, offered fresh fruits and vegetables for
many years. The warehouses that appear in the
background now house the Milwaukee Institute
of Art and Design or have been converted
to condominiums as part of the city's downtown
housing renaissance.

MILWAUKEE

NEON SIGNS

Dreamland Ballroom (1949) –
The Dreamland Ballroom was one of
Milwaukee's most prominent nightclubs
during the 1940s and 1950s. Located
at 1801 North Third Street, one block north of
the Schlitz Brewing Company, the ballroom
attracted nationally known celebrities
and touring Big Bands. Its stylish neon
sign summons dancers to the venue.

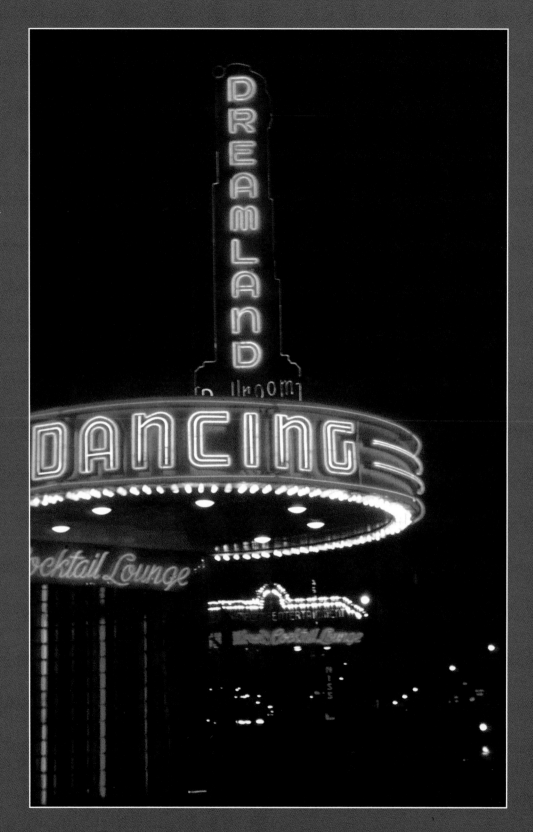

Chicago & Northwestern "400s,"
East Wisconsin Avenue (1948) –
This neon sign advertising the signature trains of the
Chicago & Northwestern Railroad was located near
the line's lakefront depot at the foot of Wisconsin
Avenue. The "400s" took their name from their
then-remarkable ability to cover the 400 miles from
Chicago to Minneapolis – St. Paul in 400 minutes.

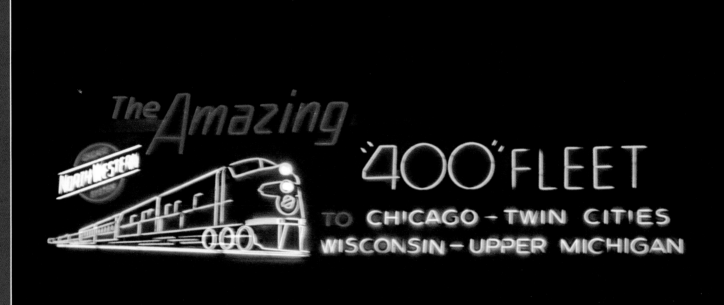

Howard Johnson's Restaurant (1968) –
The nationally recognized neon sign
illustrating how "Simple Simon met a Pie Man
going to the fair" marked the location of the
Howard Johnson's Restaurant at Southgate,
Milwaukee's first shopping center. Situated
on South Twenty-seventh Street near
Morgan Avenue, Southgate opened in 1951.
It was one of three shopping centers conceived
by Kurtis Froedtert, the head of a malting
company who sought to diversify following
World War II. Composed of twenty stores
under a single roof, Southgate offered
105,000 square feet of retail space and parking
for 2,000 cars. However, when the 1970s
brought a new wave of larger shopping malls,
Southgate was no longer able to compete.
The facility was demolished in 1999 to
make way for new development.

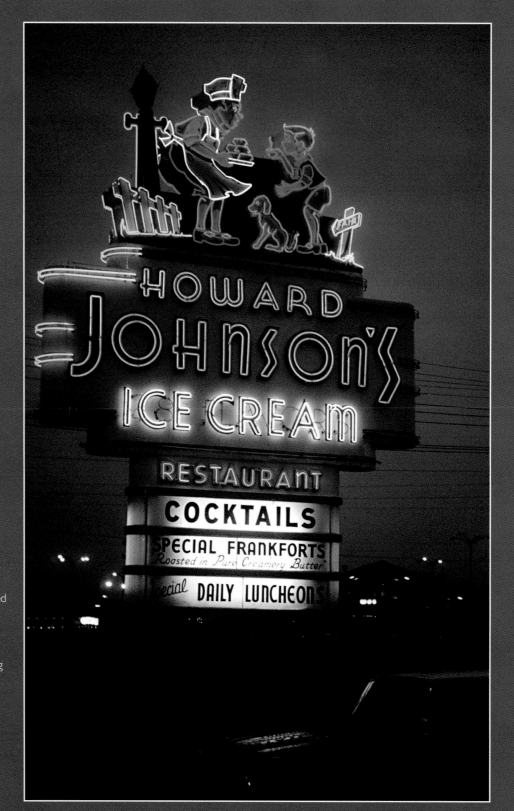

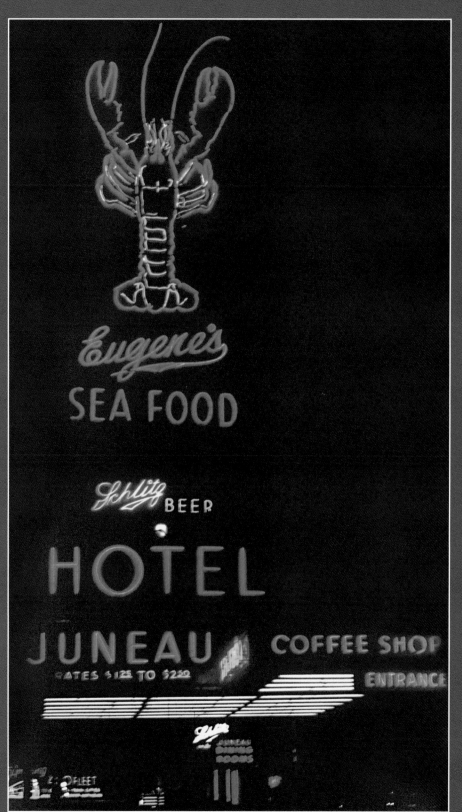

Eugene's Restaurant (1948) –
Like Frenchy's, Eugene's Restaurant
was among Milwaukee's finest eating places.
Eugene Trimberger established the restaurant
in the Juneau Hotel on Wisconsin Street
(now East Wisconsin Avenue) in 1919.
The specialty of the house – fresh seafood –
was clearly indicated by the red lobster-shaped
neon sign which became the restaurant's
trademark. Eugene's closed temporarily in 1963
when the hotel was razed to make way
for the construction of the Juneau Square office
complex. It re-opened in 1965, occupying
most of the street floor of a new nine-story
building at the same location. However,
the new restaurant never gained the acceptance
of the old, and Eugene's closed in 1974.

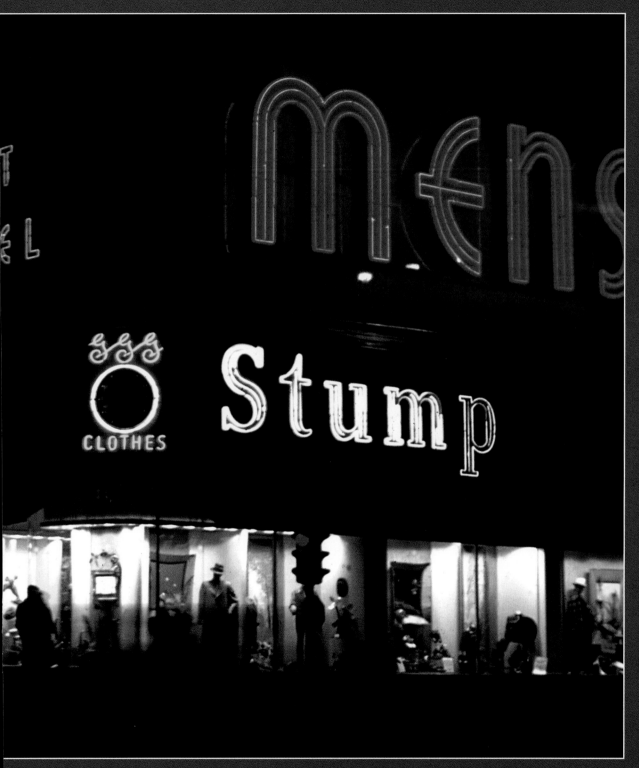

Stumpf's Men's Clothing (1946) –
Although the neon signs would seem
to indicate that this downtown men's store
was called "Stump's," the retailer's actual
name was "Stumpf's." Located on the
northwest corner of the intersection
of North Plankinton and West Wisconsin
Avenues, Stumpf's men's wear was a popular
downtown shopping destination. Later,
Stumpf's would merge with another local
men's store called Schmitt-Orlow's.
Today, Mo's Irish Pub stands at the location
of the Stumpf's store pictured.

Humphrey Chevrolet (1946) –
Humphrey Chevrolet was a fixture
on the southeast corner of North Thirty-fifth
Street and West Wisconsin Avenue for
decades. Throughout this period, the
car dealer made ample use of neon in calling
attention to his showroom. Today,
Marquette University High School's Humphrey
Athletic Field occupies the site of the
former Chevy dealership.

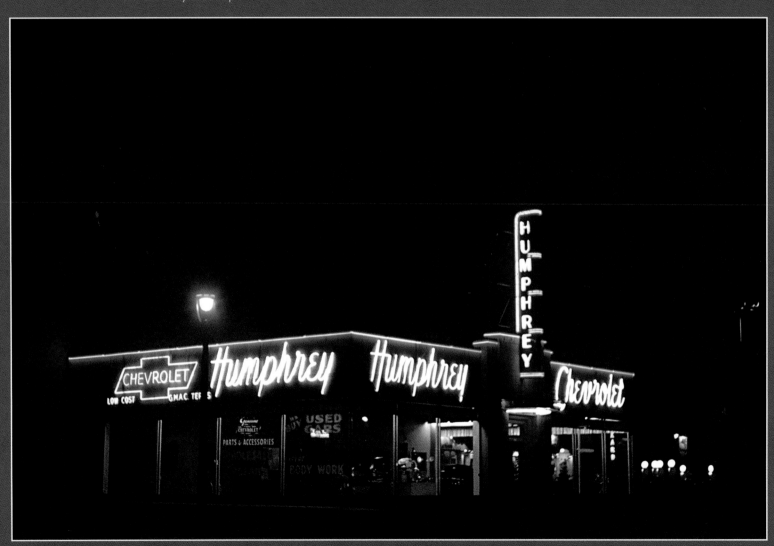

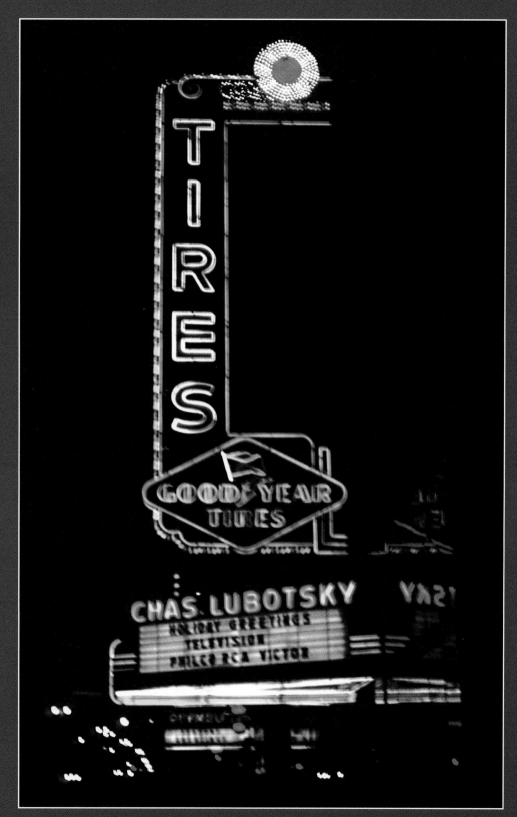

**Chas. Lubotsky Tires,
Batteries and Recaps (1948) –**
Auto supply stores, like automobile
dealerships, relied on neon signs to keep
their products in the public eye.
The large Goodyear Tires sign above
the marquee of the Chas. Lubotsky
tire store serves just such a purpose.

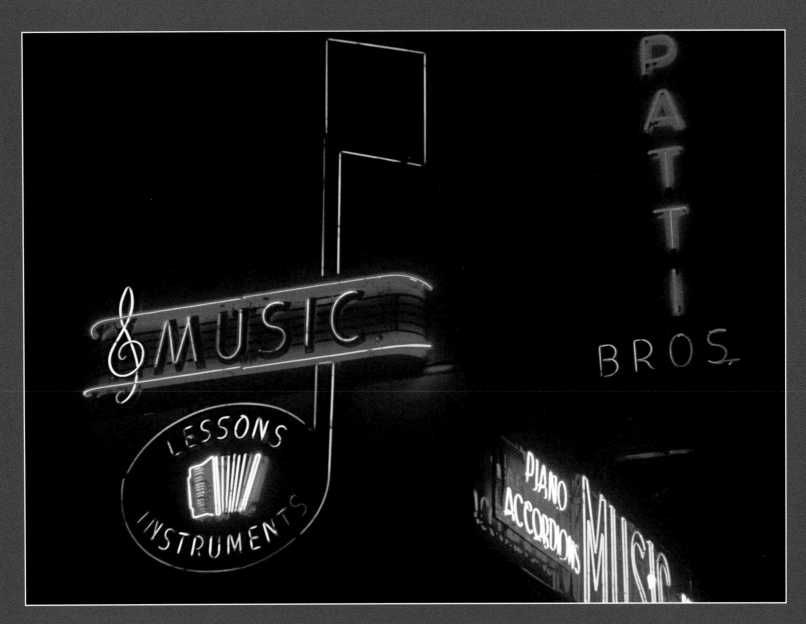

Patti Bros. Music (1949) –
Located at 2050 North Third Street,
just a few blocks south of West North Avenue
in the popular Third Street shopping
district, Patti Bros. Music offered
both instruments and lessons to prospective
musicians. Given Milwaukee's high
concentration of European ethnic communi-
ties, the accordion remained a popular
instrument well beyond the date
of this photograph.

Henry Colder Co.,
Milwaukee's Freezer Center (1954) –
Located at 1825 W. Fond du Lac
Avenue, the Henry Colder Co. specialized
in commercial and residential refrigeration
equipment. Still in business to this day,
Colder's has stores throughout the
Milwaukee metropolitan area and
sells furniture as well as appliances.

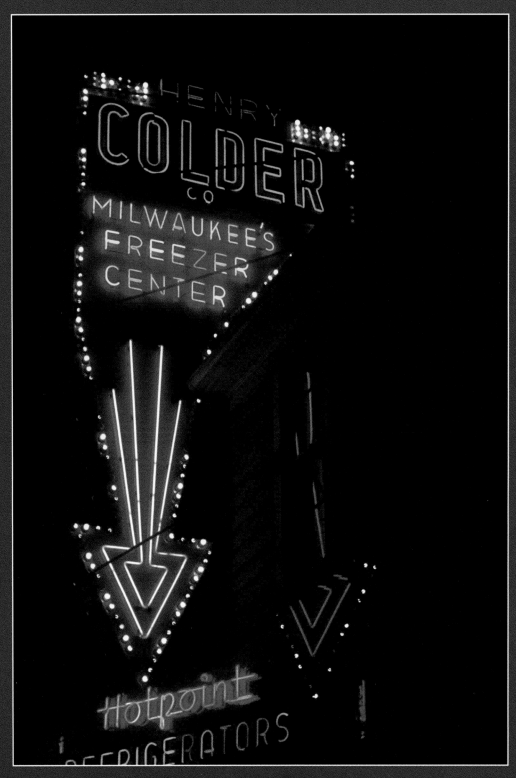

Holiday Lights,
West Wisconsin Avenue (1965, 1949) –
This view of West Wisconsin Avenue from the Milwaukee River captures the brightly illuminated holiday decorations spanning Milwaukee's main street, as well as the multi-story Christmas tree attached to Gimbels Department Store. A favorite pastime for families during the annual holiday season was to travel downtown to see the animated display windows at Gimbels and the Boston Store. However, Milwaukee's most popular holiday figure – Billie the Brownie – appeared only in the windows of outlying Schuster's Department Stores. (See inset.)

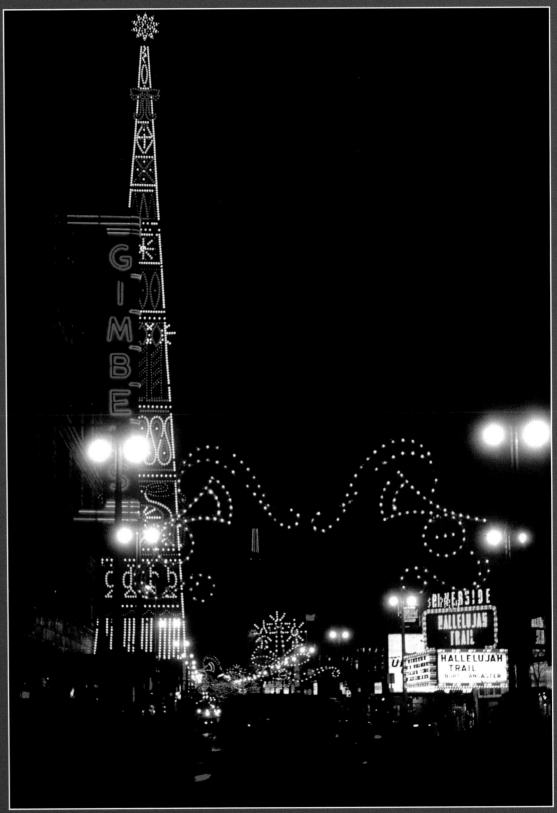

MILWAUKEE

TRANSPORTATION

Milwaukee Road Depot (1948) –
Designed by Edward Townsend Mix and constructed in 1884, the Milwaukee Road Depot stood on Everett and Third Streets, several blocks north of the Menomonee River. The imposing tower of the Germanic Renaissance structure deteriorated over the years and was removed in 1951-1952. Following a fire, the building was razed in 1965. During the mid-1980s, Wisconsin Electric Power Company, now known as We Energies, added a five-story annex and parking structure on the site. Hiawatha Baltic No. 102 – a 4-6-4 shrouded steam locomotive – departs the train shed heading east in this classic photograph.

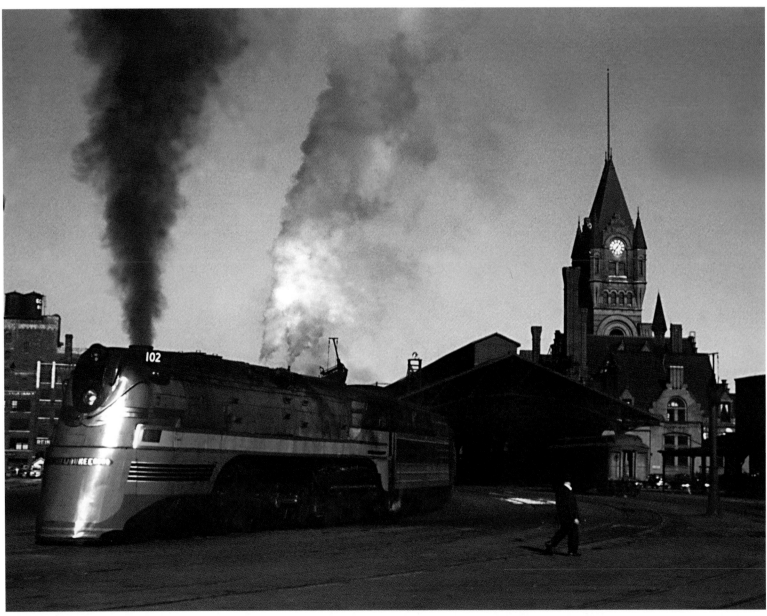

Hiawatha Skytop Lounge Car (1950) –
The signature train of the Milwaukee Road,
the Olympian Hiawatha benefited from the
contemporary design of Milwaukeean Brooks Stevens.
Here, his Skytop Lounge Car, introduced in 1947
on new Twin Cities Hiawathas, awaits passengers
at the west end of the Milwaukee Road Depot.

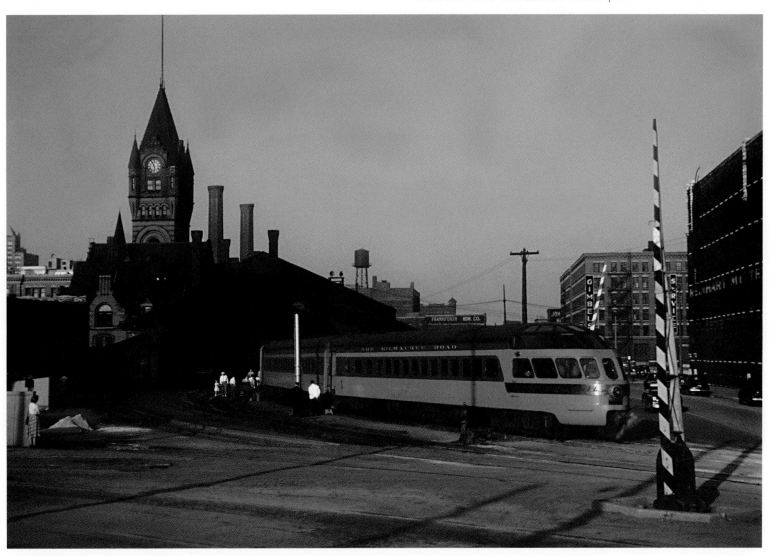

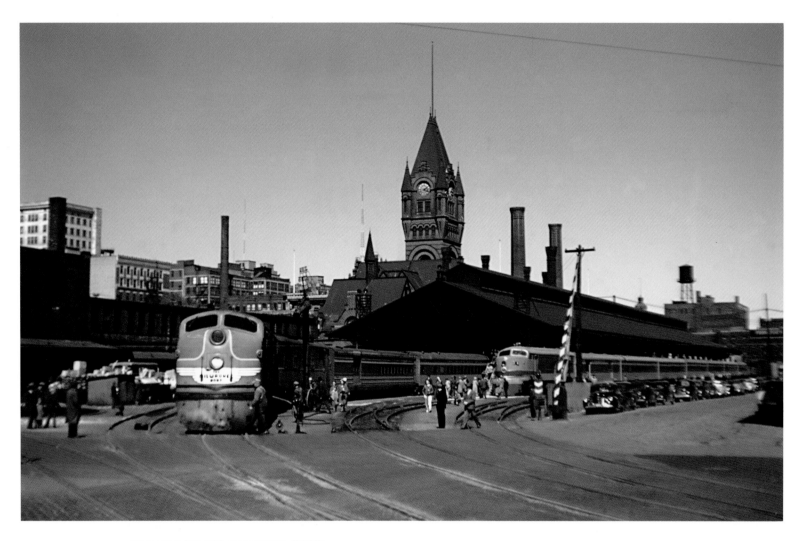

Hiawatha Diesel Locomotives (1948) –
The new diesel-electric locomotives that powered
the Milwaukee Road's Hiawatha enjoyed streamlined
design similar to that of earlier steam engines.
Here two diesels with two different paint schemes –
one the gray and orange livery of freight engines,
the other the orange and maroon of passenger
engines – pull a pair of trains heading west out of
the Milwaukee depot.

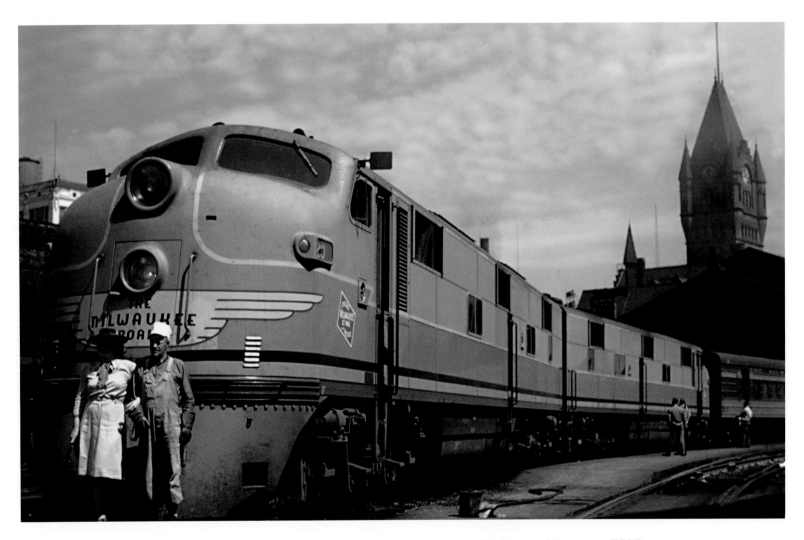

Engineer and Passenger (1946) –
A Milwaukee Road engineer, dressed in his "hickory-striped" overalls and wearing a white hat indicative of his position, poses with a woman in a yellow dress and large black hat immediately in front of a westbound diesel engine stopped in the Milwaukee depot.

**Milwaukee Road Steam
Locomotives and Tenders (1954) –**
While diesel power began to replace steam
for passenger trains in the late 1940s, freight
trains were still being pulled by smoke-belching
steam locomotives well into the 1950s.
This image, taken from the Thirty-fifth Street
viaduct, shows a number of steam locomotives
and their coal tenders in the Milwaukee Road
yards in the Menomonee Valley. Because
it could take several days to fire up a steam
locomotive, engines were kept fueled
and "fires banked" so that the locomotives
could be put into service more quickly.

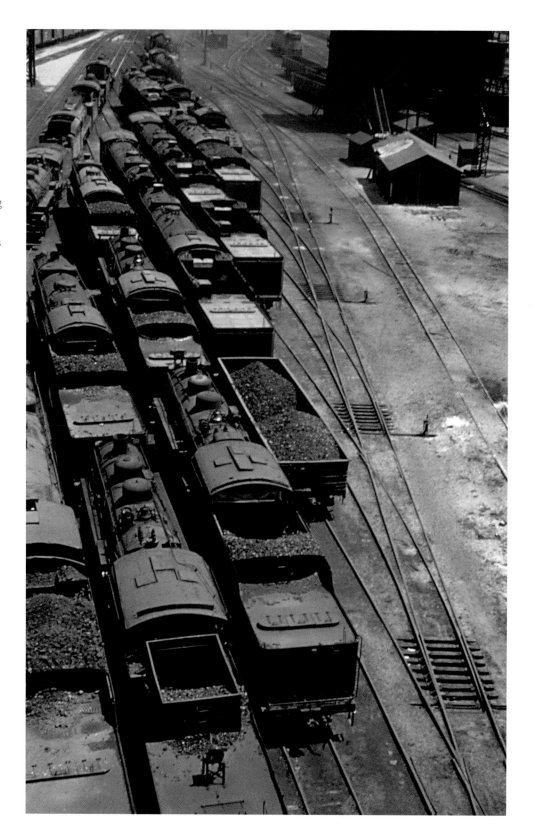

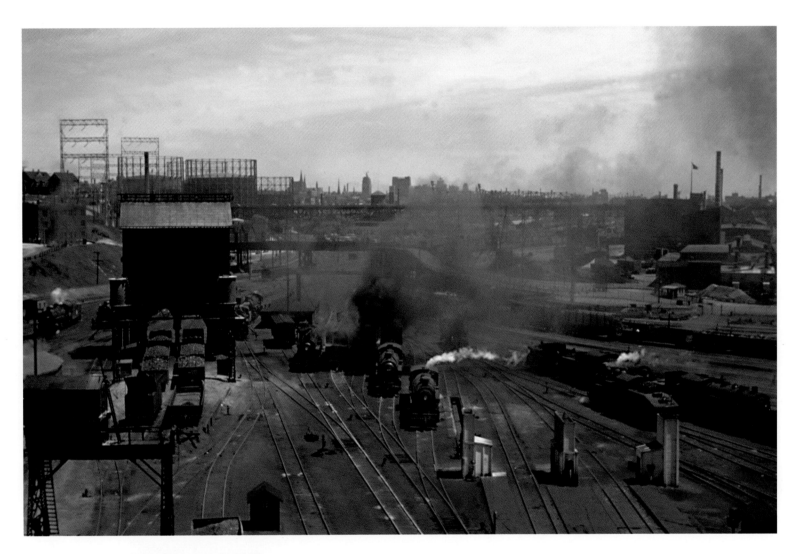

Roundhouse Yards (1946) –
The Milwaukee Road's roundhouse was
located at the western end of the Menomonee
River Valley, just past the Thirty-fifth Street
viaduct. This image taken from the overpass
looking east toward downtown captures
a number of locomotives gathering steam in
the roundhouse yard.

Chicago & Northwestern Depot (1948) –
The Richardsonian Romanesque Chicago & Northwestern Depot,
designed by Charles Sumner Frost and completed in 1889, was
a landmark at the foot of Wisconsin Street (now East Wisconsin Avenue)
for decades. This photograph taken from the north captures the depot,
its massive tower and the iron-framed train shed that extended out
toward Lake Michigan. The depot proper housed a large waiting room, a
hotel, a restaurant and office facilities. The building was razed in
1968 after the railroad transferred its freight and passenger operations to
the new railroad station on St. Paul Avenue in 1966. Bluff Park
succeeded the old Chicago & Northwestern Depot in 1983, and during
the 1990s the O'Donnell Park complex was completed on the site.

Chicago & Northwestern 400s at the Depot (1956) –
Two Chicago & Northwestern 400s pass in opposite
directions on the tracks behind the Milwaukee lakefront
depot. Peninsula No. 209 is northbound, while Twin Cities
No. 400 is southbound. The time of day would have been
roughly 5:30 p.m. – the only time the two trains would
have passed one another at this location.

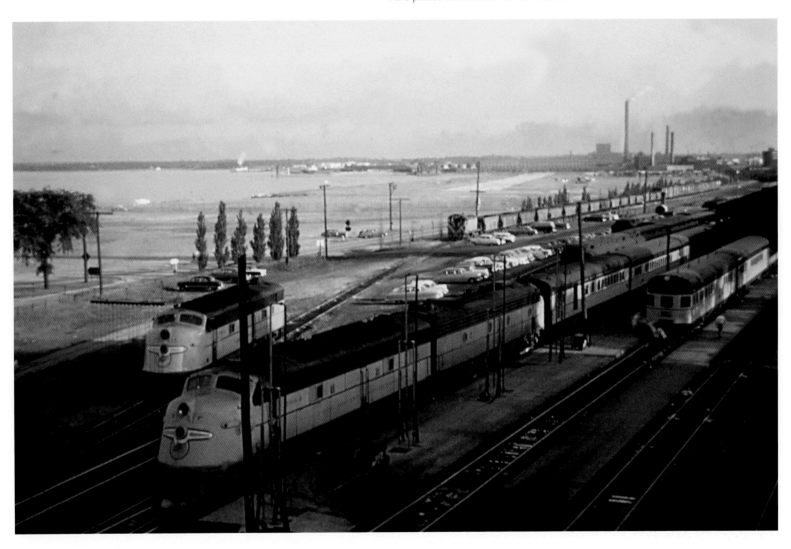

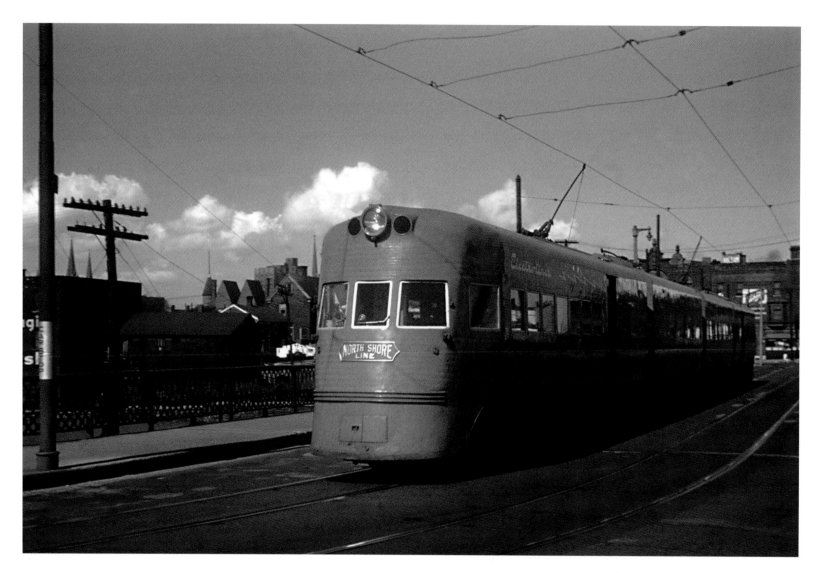

North Shore Line Electroliner (1948) –
The Chicago, North Shore and Milwaukee Railroad
first placed Electroliners into service in 1941 on the
route between Chicago and Milwaukee. The four-unit
articulated trains were the first of their kind, capable of
negotiating the narrow elevated tracks in downtown
Chicago and of covering extended interstate routes as
well. The Electroliners served the North Shore Line's
main Milwaukee station at North Sixth and West
Michigan Streets, providing passenger service until 1963.

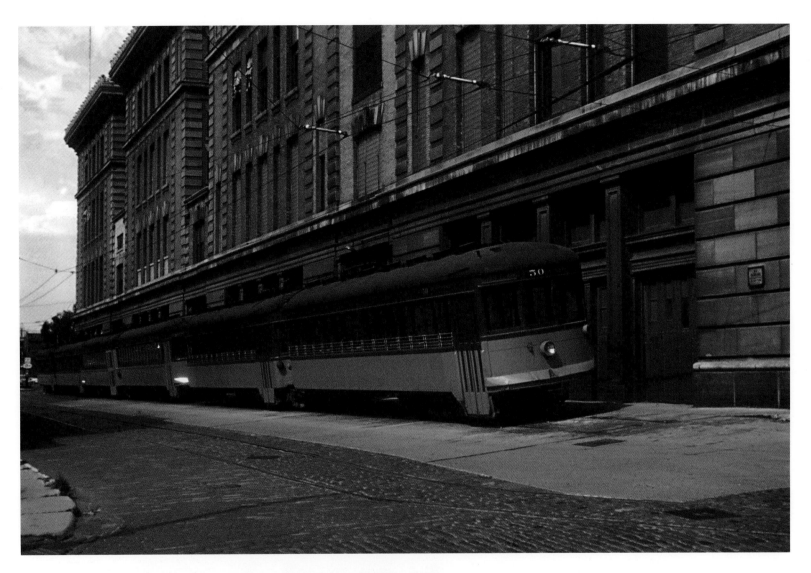

Speedrail Trains Beside the Public Service Building (1950) –
The Milwaukee Rapid Transit and Speedrail Company was established in
January, 1950 to operate the last two remaining legs (Waukesha and Hales
Corners) of the interurban system developed by The Milwaukee Electric
Railway and Light Company over the previous fifty-five years. Unfortunately,
a head-on collision on the Hales Corners line in September of the same
year left ten passengers dead and many others injured. This catastrophe
led to the abandonment of the line after only twenty-two months of
operation. Here Speedrail cars are parked alongside the Public Service Building
on North Second and West Michigan Streets. Designed by Herman J. Esser
and completed in 1905, the facility served as the main office, central
car shop and terminal for TMER&L and later for Speedrail.

Snowplow (1947) –

In order to clear the snow from the streetcar tracks
that ran down the middle of many Milwaukee streets,
The Milwaukee Electric Railway and Light Company
utilized a massive snowplow mounted on a streetcar
body. Painted "work car yellow," it was powered
by electricity from the same overhead lines the trolleys
used. Given the date of the photograph, this snowplow
may have just completed clearing snow following
the "Blizzard of 1947."

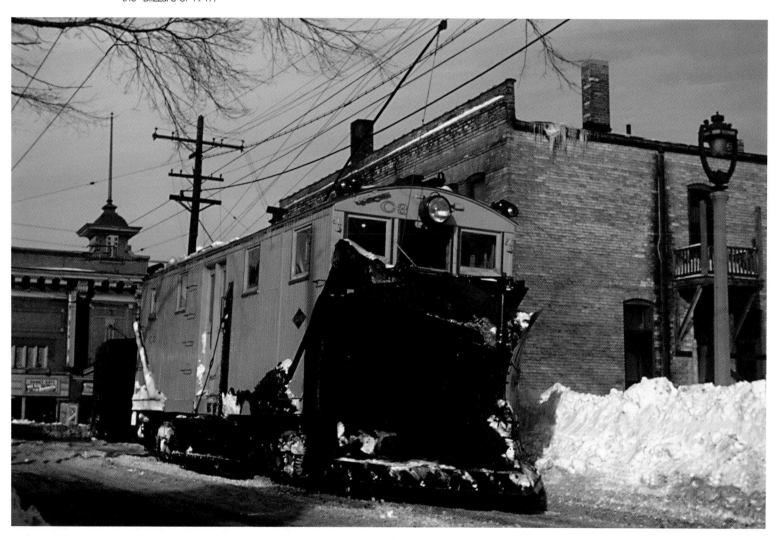

Streetcar Exiting Wells Street Viaduct (1953) –
This No.10 streetcar exits the west end of the
Wells Street viaduct just five years before all trolley
transportation would be discontinued in Milwaukee.
Streetcar service, begun in 1890 and provided for many
years by The Milwaukee Electric Railway & Light
Company, was Milwaukee's principal form of mass
transit for nearly seventy years. The No. 10 Wells Street
line was the last to be discontinued in the city,
coming to an end in 1958.

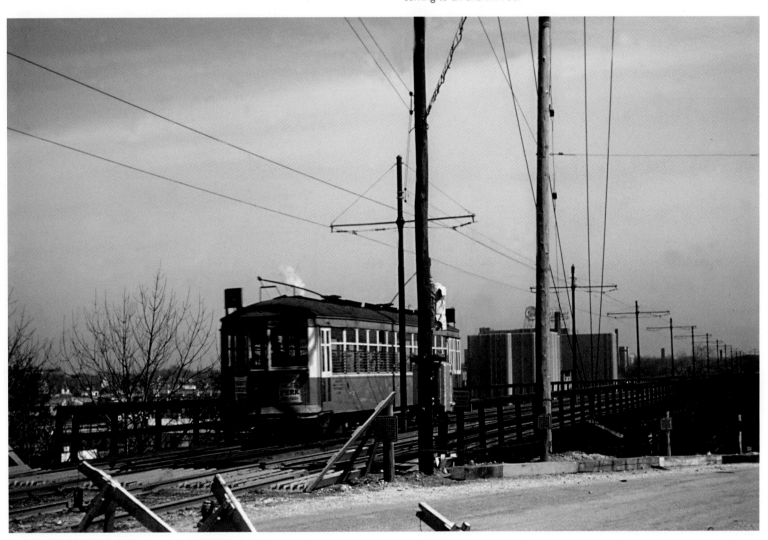

Wadhams Gas Station (1946) –
In 1917, the Wadhams Oil Company commissioned noted
Milwaukee architect Alexander Eschweiler to design a gas station
that would be immediately recognizable to its customers.
Eschweiler responded with the red-roofed, pagoda-style station
that immediately became the company's trademark.
The Wadhams station at North Twenty-seventh Street and
West Wisconsin Avenue was among the largest of the forty
stations constructed in the Milwaukee area during the 1920s and
1930s. A modern Mobil station currently occupies the site.

**Automobiles on
Lincoln Memorial Drive (1954) –**
Like many other Americans who suffered the restrictions of the Depression and World War II, Lyle Oberwise appreciated the availability of new automobiles during the late 1940s and 1950s – although he himself never drove. He documented automobiles at auto shows, in the showroom and on the road. Here Oberwise captures traffic on Lincoln Memorial Drive, the beautiful stretch of lakefront roadway completed in 1929 following years of landfill activity.

Auto Transport Trailers (1947) –
New 1948 Buicks and Oldsmobiles
await delivery aboard a fleet of streamlined
auto transports.

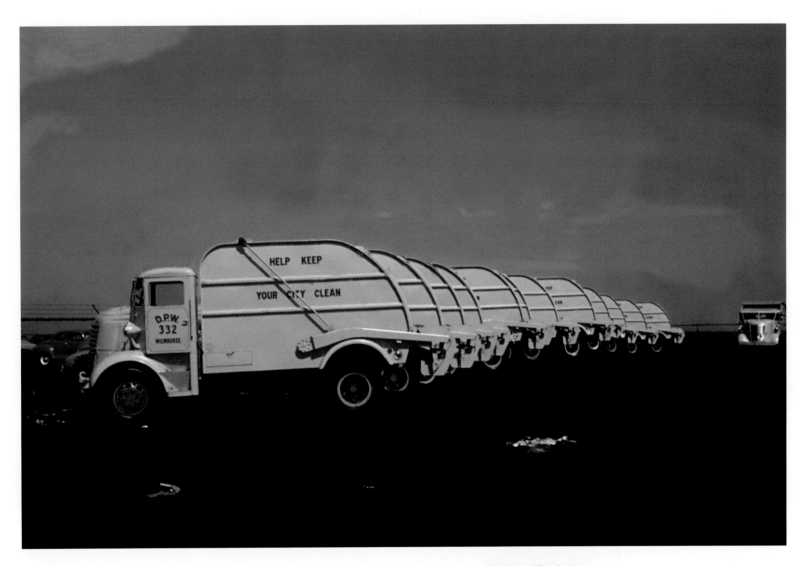

On the truck: HELP KEEP YOUR CITY CLEAN

D.P.W. 332 MILWAUKEE

Garbage Trucks in D.P.W. Yard (1948) –
A row of bright yellow Milwaukee garbage trucks in a Department of Public Works yard provides Lyle Oberwise with an ideal subject for exploring color contrast and spatial depth.

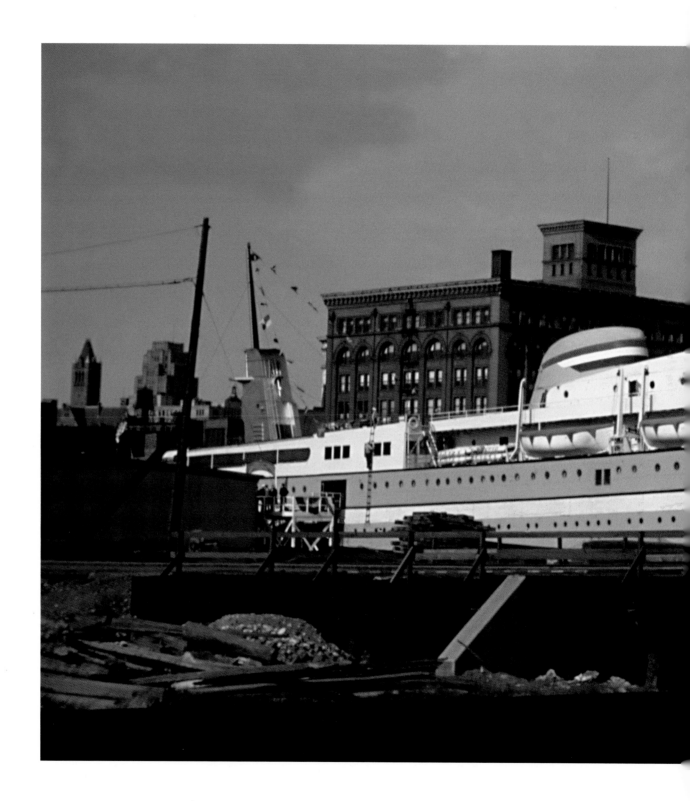

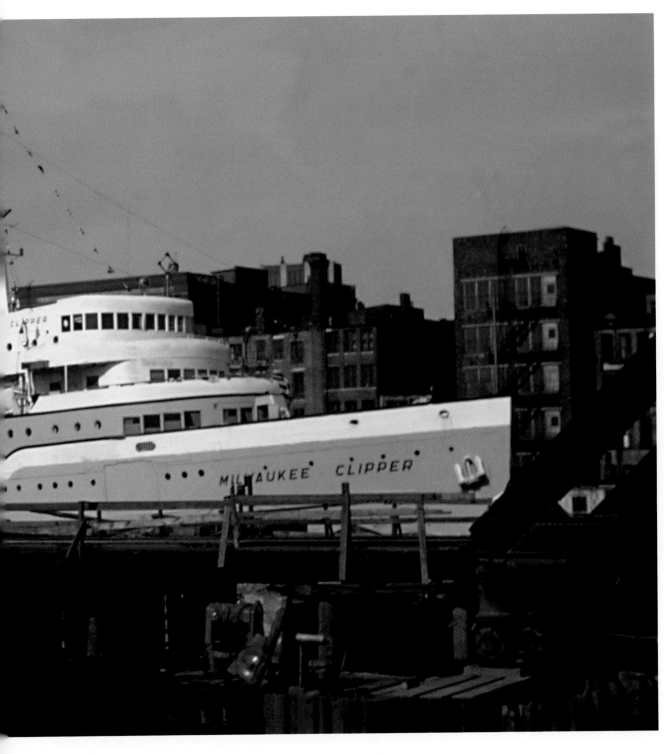

Milwaukee Clipper (1946) –
The *Milwaukee Clipper* was originally constructed in 1904 by the Erie & Western Transportation Company as a Great Lakes passenger and package freight steamer. Christened the *Juniata,* the ship provided first class accommodations from Buffalo to Duluth for over thirty years. Retired from service in 1937 due to new safety requirements, it was purchased in 1940 and refurbished with a streamlined, all-steel superstructure at the Manitowoc Shipbuilding Company. From 1941 until 1970, the newly renamed *Milwaukee Clipper* carried thousands of passengers and automobiles from Milwaukee to Muskegon, Michigan. The *Clipper* is shown on the Milwaukee River, a short distance upstream from its dock at 601 East Erie Street. The vessel is currently docked in the Muskegon harbor where it is undergoing restoration by the Great Lakes Clipper Preservation Association.

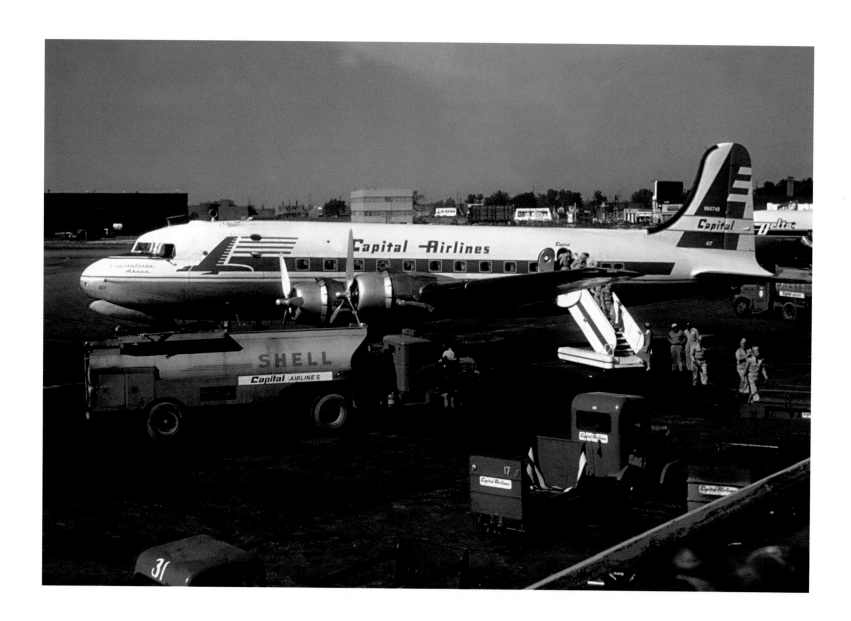

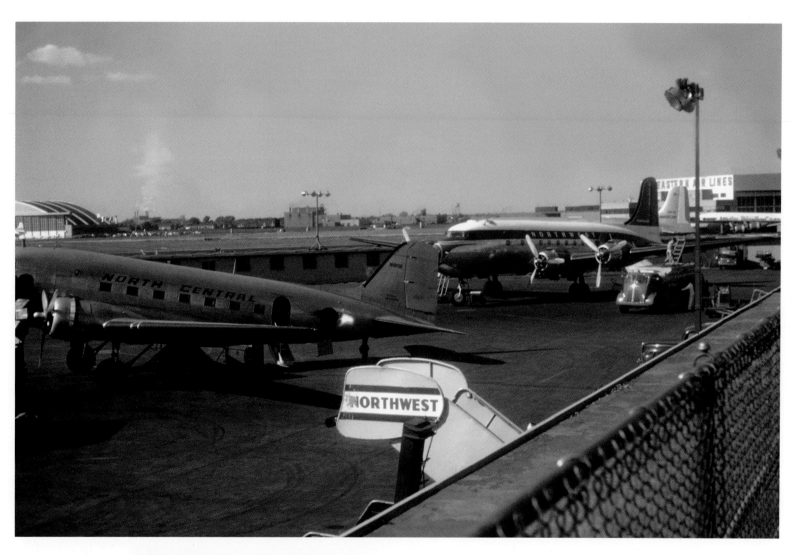

Capital Airlines DC-6 at Mitchell Field (1954)
North Central DC-3 and Northwest Airlines DC-6
at Mitchell Field (1954) –
The Milwaukee County Board of Supervisors purchased the
property that would become General Mitchell Field in 1926 from
local aviator and propeller manufacturer Thomas Hamilton.
Northwest Airlines began air service from Milwaukee to Chicago and
the Twin Cities in July, 1927. During the last years of the Depression,
between 1938 and 1940, the Works Progress Administration
built a new two-story terminal building along Layton Avenue.
These images of aircraft operated by Capital, North Central and
Northwest Airlines were taken from that terminal building.

Maitland Airport (1952) –
Maitland Airport, commonly known as Maitland Field, opened
in 1927, one of the first downtown airports in the United States.
It was named after Lester Maitland, a Milwaukee-born aviator who
completed the world's first trans-Pacific flight earlier that year.
The field, described as an "Air Marine Terminal" in the 1934
Department of Commerce Airfield Directory, offered a landing
strip and sea ramp for pontoon planes landing on the lake.
Never very successful, the airport was replaced in 1956 by an
Army Nike Missile Launch Site. The "Nike site" was, in turn,
replaced in 1970 by Summerfest, and the property was renamed
Henry W. Maier Festival Park in 1986 in honor of Milwaukee's
longest-serving mayor.

MILWAUKEE

DEMOLITION AND DESTRUCTION

**Demolition of the
Elizabeth Plankinton Residence (1980) –**
Designed by Edward Townsend Mix, the
Richardsonian Romanesque residence on
Fifteenth Street and Grand (now West
Wisconsin) Avenue was built as a wedding gift
for Elizabeth Plankinton by her millionaire
meat packer father around 1890. When the
wedding was called off, she rejected the house
after setting foot in it only once. From 1910 on,
the building served as the home of the
Milwaukee chapter of the Knights of Columbus.
Despite its listing on the National Register of
Historic Places, Marquette University razed the
Plankinton residence in 1980; the site is now
the location of the Alumni Memorial Union.

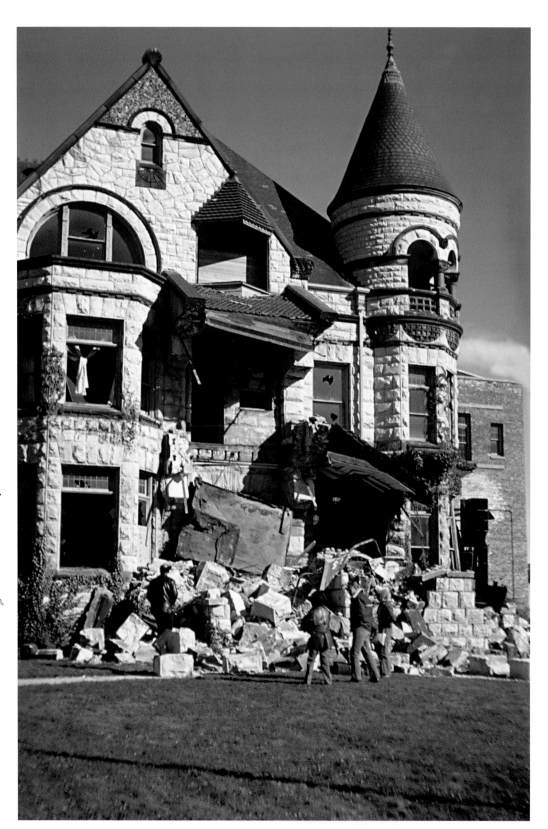

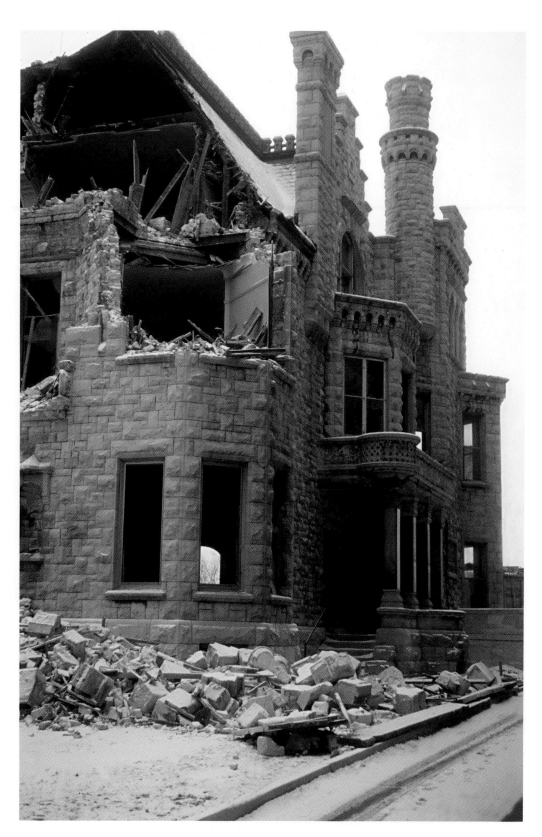

**Demolition of the Benjamin "Castle"
on North Prospect (1963) –**
David M. Benjamin came to Milwaukee
around 1887 and enjoyed success
in the lumber business. About 1890, he built
a turreted stone "castle" on Prospect Avenue,
one of the many private residences
that once lined the street. The Benjamin
residence was torn down in 1963.

**Demolition of the
First Methodist Church (1968) –**
The First Methodist Church, constructed
in 1908 on Eleventh Street and Grand
(now West Wisconsin) Avenue, was razed in
1968 to make way for expressway construction.
The congregation had previously merged
with the Wesley Methodist Church.
The Milwaukee County Courthouse and the
Wisconsin Club are visible in the background.

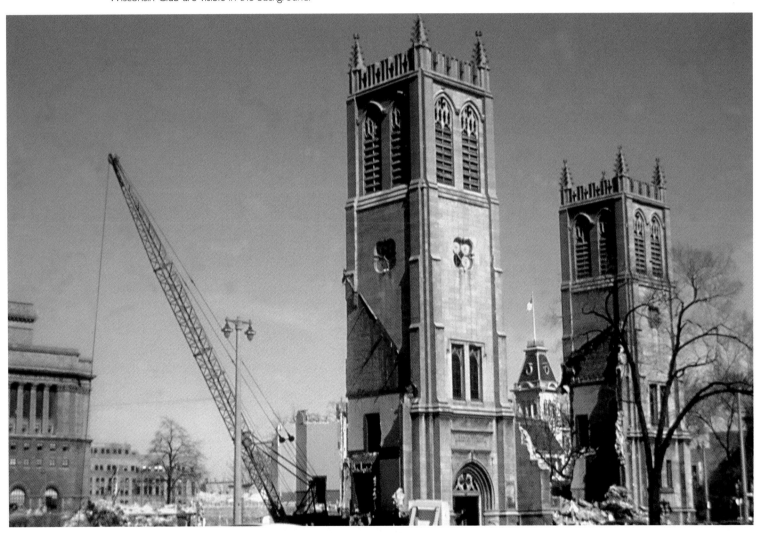

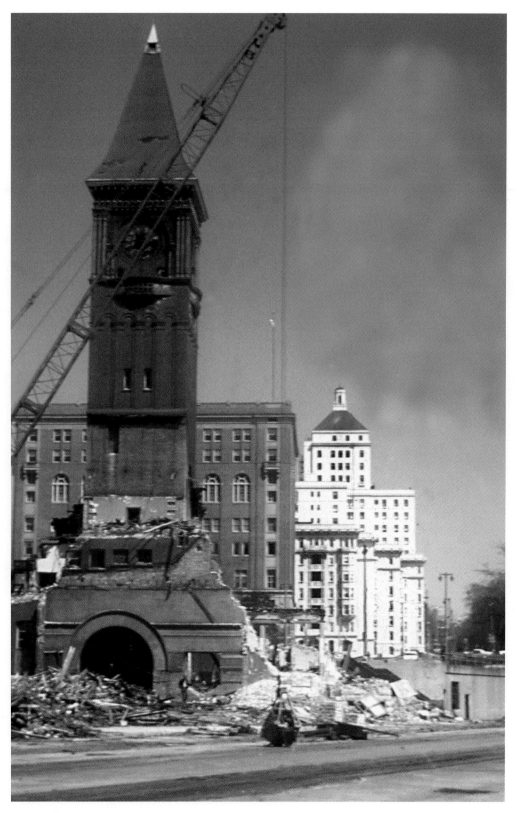

Demolition of the Chicago & Northwestern Depot (1968) –
This image of the demolition of the Chicago & Northwestern Railroad Depot shows only the clock tower standing in front of the Elks Club and the Cudahy Towers. The demolition of the depot, along with the 1967 demolition of Our Lady of Pompeii Church in the Third Ward, prompted a greater awareness of the importance of historic preservation among the people of Milwaukee.

Metropolitan Block Fire: Third Street (1975) –
North Third Street between West State Street
and West Highland Boulevard was closed to all traffic
except for fire equipment and emergency vehicles during a
blaze that gutted the Metropolitan Block Building on
December 20, 1975. Built in 1896, the four-story
building housed a number of business offices on the
upper floors, including those of the Socialist Party, as well
as retail establishments on the ground level. Although
the fire left the building intact below the third floor,
the city ordered it demolished. Today, Usinger's parking lot
is located where the Metropolitan Block once stood.

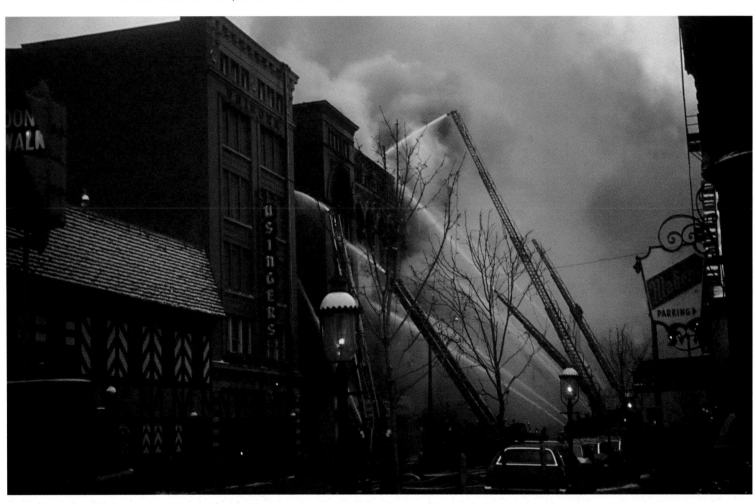

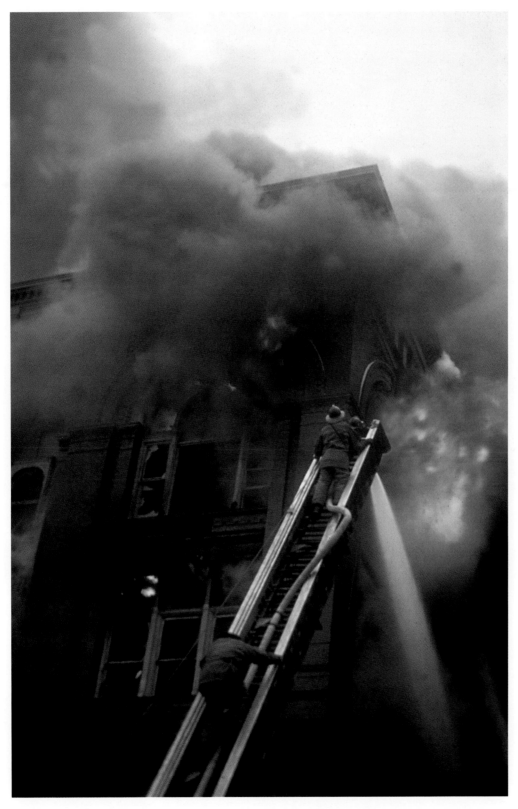

**Metropolitan Block Fire:
Aerial Ladder (1975) –**
Although Lyle Oberwise never drove
a car, the fact that he lived downtown on East
State Street enabled him to travel to
the scenes of accidents and fires in enough
time to record them with his camera.
Here, Oberwise documents a fireman on an
aerial ladder fighting the Metropolitan Block fire.

**Metropolitan Block Fire:
Fireboat (1975) –**
Because the Metropolitan Block
was located just to the south of Usinger's
Famous Sausage along the Milwaukee River,
the Milwaukee Fire Department's
fireboat *Deluge* was able to assist in
fighting the blaze.

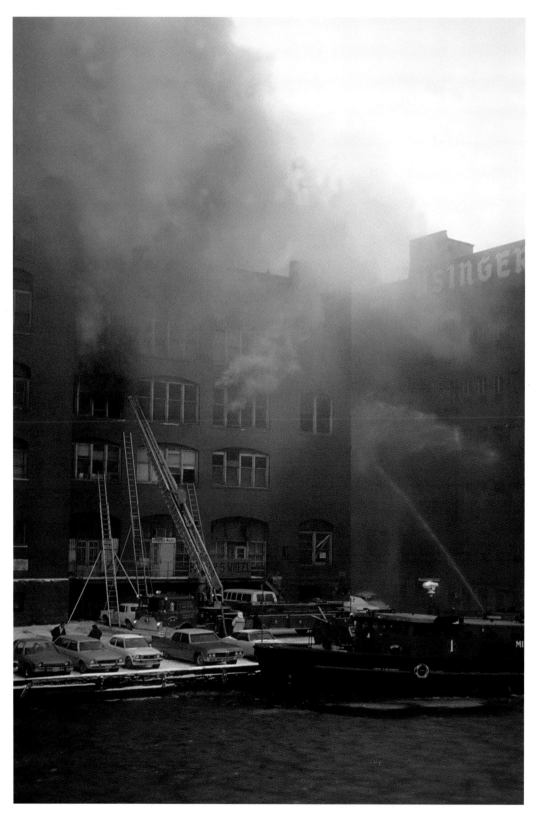

Church Fire (1974) –
Milwaukee firefighters attempt to extinguish
flames that had already burned through
the roof of the First Baptist Church in December,
1974. Located at the intersection of North
Marshall and East Ogden Streets, the church was
founded in 1842. However, within just a
year after the blaze, the building was demolished.

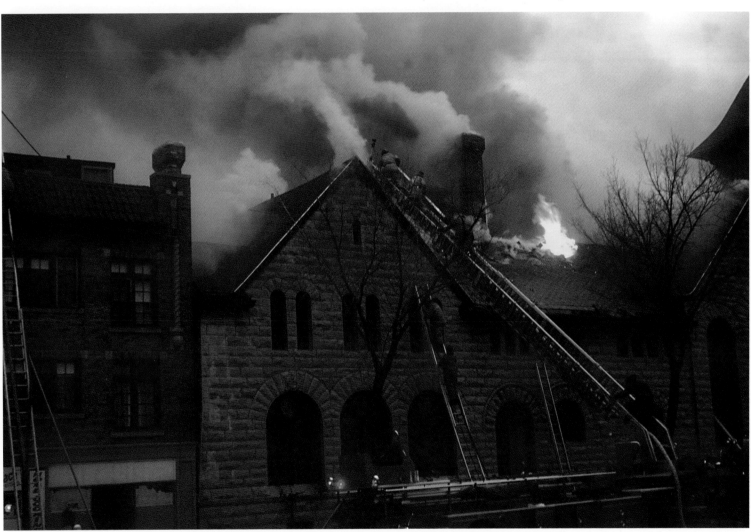

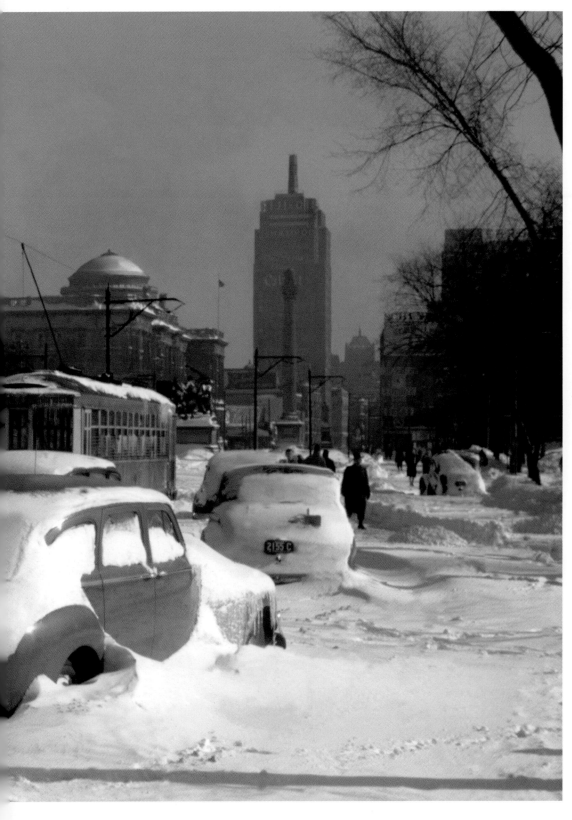

The Blizzard of 1947: West Wisconsin Avenue (1947) –
Over a period of three days, from January 28 through January 30, 1947, more than eighteen inches of snow fell on Milwaukee and sixty mile per hour winds created drifts of ten feet or more. The legendary "Blizzard of '47" left the city paralyzed and required a full forty-six days to clean up. In this image looking east along West Wisconsin Avenue from North Eleventh Street, the First Methodist Church appears in the foreground and the Public Library in the background. Stranded cars litter Milwaukee's main street between the two buildings.

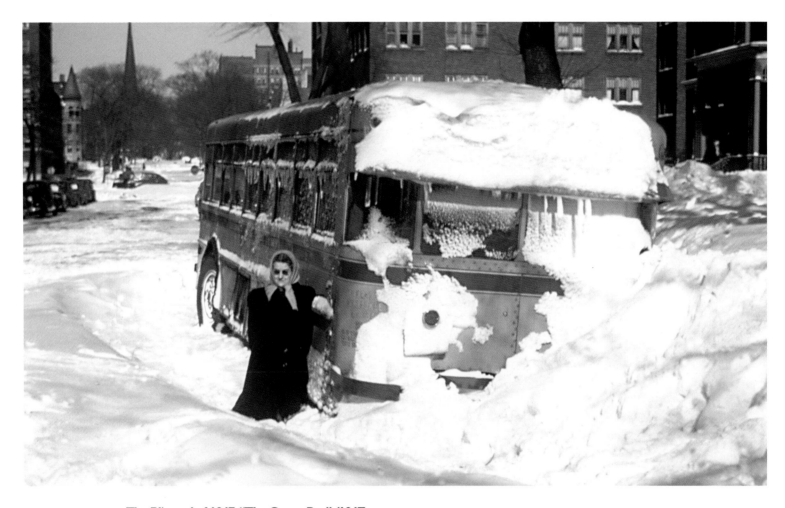

The Blizzard of 1947: "The Green Bus" (1947) –
An unidentified woman stood in front of a "Green Bus" abandoned
during the "Blizzard of '47" on North Maryland Avenue.
The Green Buses were operated by Wisconsin Motor Bus Lines,
a subsidiary of The Milwaukee Electric Railway and Light Company
founded in 1923 to counteract competition from jitney buses
and automobiles. While they charged a slightly higher fare than other
city buses, the Green Buses provided deluxe service and
guaranteed seating. Their route followed North Maryland and
Prospect Avenues from East Edgewood Avenue to downtown, then
Wisconsin Avenue, Highland Boulevard, Thirty-ninth Street and
Sherman Boulevard to Capital Drive on the Northwest Side.
WMBL was absorbed into the streetcar, trackless trolley and auxiliary
bus system under orders from the Public Service Commission in 1950.

INDEX

INDEX